ROMAN ART

ROMAN ART

General Editor
Francesco Abbate

Translated by
A. J. Sutton

Octopus Books
London · New York · Sydney · Hong Kong

English version first published 1972 by
Octopus Books Limited
59 Grosvenor Street, London W1
Translation © 1972 Octopus Books Limited

Distributed in Australia by
Angus & Robertson (Publishers) Pty Ltd
102 Glover Street, Cremorne, Sydney

ISBN 7064 0059 3

Originally published in Italian by
Fratelli Fabbri Editore
© 1966 Fratelli Fabbri Editore, Milan

Printed in Italy by Fratelli Fabbri Editore

CONTENTS

ART IN REPUBLICAN ROME

When Cato the Censor (234–149 BC) ferociously and intransigently condemned the passion, widespread among the Romans of his day, for refined and luxurious objects, and for decorating their houses in a rich and splendid manner, he was fighting the tide of history. There was by then a new interest in art, which came to be regarded as a pleasant embellishment to the daily round, and the more severe attitudes of former times were gradually abandoned. In the field of the figurative arts, this brought a progressive Hellenization of Roman culture, and a turning away from those traditional ideas that had seen in art a corrupting influence on morals, and had only accepted it grudgingly for purposes of religious observance and of extolling the grandeur of Rome.

The sober purity of the ancient clay deities had until then represented the last word in permissiveness: for people to replace these with sumptuous images in the 'Greek manner' was felt by Cato to be a dreadful scandal and a betrayal of the Rome that their ancestors, from the time of Romulus, had handed down to them.

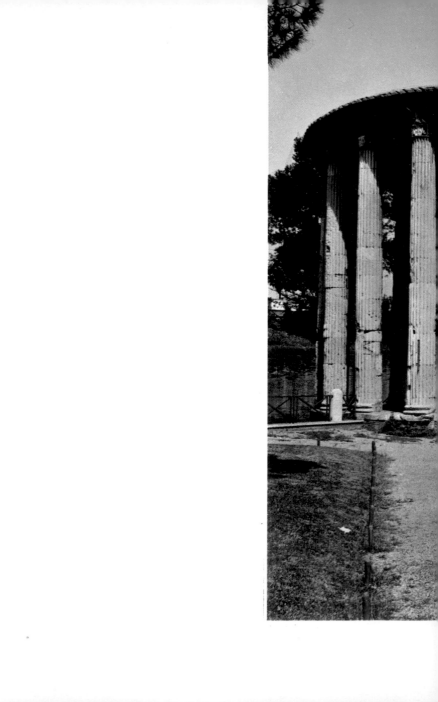

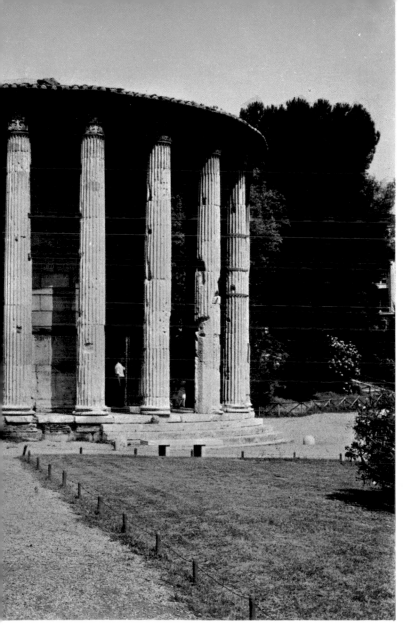

1 *Roman art : Circular temple by the Tiber, Rome. 1st century BC.*

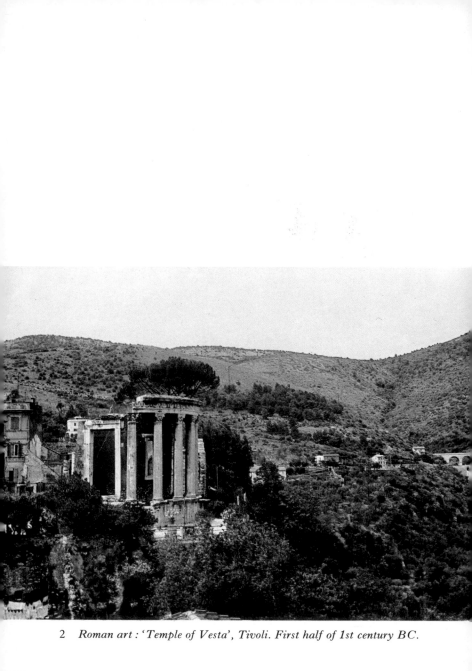

2 *Roman art : 'Temple of Vesta', Tivoli. First half of 1st century BC.*

3 *Roman art : Temple of Hercules Sulxanus, Cori. Beginning of*
1st century BC.

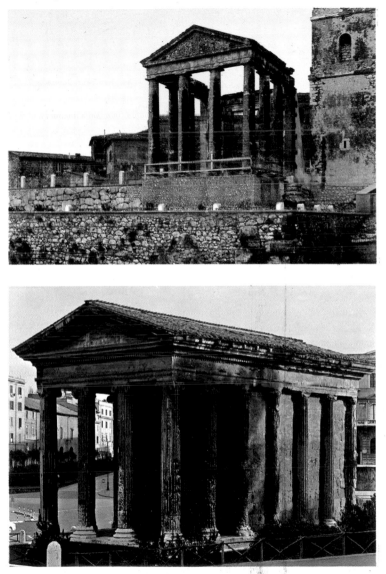

4 *Roman art : Temple of Fortuna Virilis, Rome. 42–38 BC.*

1 Roman art: *Circular temple by the Tiber*, Rome. 1st century BC. Originally covered with a dome, this temple, now the Church of Santa Maria del Sole, dates from the time of Sulla (138–78 BC). It is surrounded by a ring of elegant Corinthian columns.

2 Roman art: '*Temple of Vesta*', Tivoli. First half of 1st century BC.
This small temple, like the previous example, was erected on a circular plan and enriched with Corinthian columns. It probably dates from the period of Sulla's reign, which began in 85 BC.

3 Roman art: *Temple of Hercules Sulxanus*, Cori. Beginning of 1st century BC.
The colonnade of this temple shows how the Romans successfully took over and adapted the Greek Doric Order.

4 Roman art: *Temple of Fortuna Virilis*, Rome. 42–38 BC.
This temple stands on a raised platform typical of Roman temple architecture and consists of a deep colonnaded porch and a cella of equal width. It was adapted for Christian use at the beginning of the 9th century AD, and owes its excellent state of preservation to this transformation.

5 Roman art: *Substructure and ambulatory of the Temple of Jupiter Anxur*, Terracina. 1st century BC.
The extensive use of the arch permitted Roman architects to develop daring structural techniques.

6 Roman art: *Tomb of Cecilia Metella* on the Appian Way, Rome. 1st century BC.
This tomb was built about the middle of the 1st century BC, but lost some of its antique appearance in the Middle Ages when it was incorporated into a fortress built by the Caetani family. Its strange crown of battlements dates from the later period.

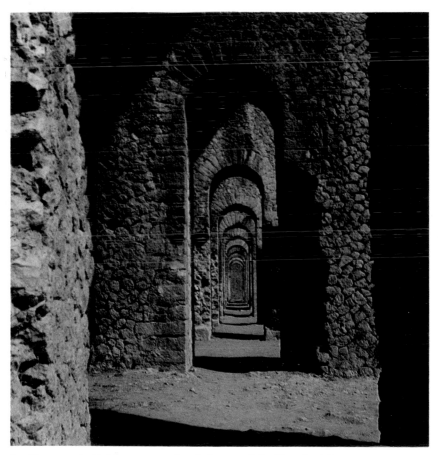

5 *Roman art : Substructure and ambulatory of the Temple of Jupiter Anxur,*
Terracina. 1st century BC.

13

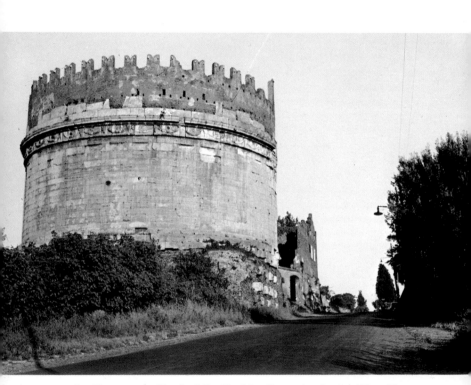

6 *Roman art : Tomb of Cecilia Metella on the Appian Way, Rome. 1st century BC.*

The earliest villages on the Palatine – where Rome, according to legend, was founded by Romulus – date from the eighth century BC and were collections of huts inhabited by shepherds of Latium whose culture was comparatively backward. Typical of their culture are a number of urns made in the form of contemporary dwelling places that feature the door, windows, roof beams and the hole in the roof through which the smoke could escape.

At this time there were few places of worship and no divine imagery. This is how Tertullian describes primitive Rome in his *Apologeticus*: 'Makeshift turf altars . . . hardly any smoke for the sacrifices and nowhere can there be seen any images of the Deity himself.' Not far away there were several Etruscan centres that were more in contact with Greece, and they had made rapid advances. As yet, however, no echo of eastern influence had reached Rome. In the valley at the foot of the hills – in the place where the Forum would arise – was a primitive and poor necropolis. At the end of the seventh century BC Rome came under Etruscan rule. Her strategical position on the road to Campania was of interest to the Etruscans who wanted to expand to the south. This was the period when Rome first acquired an urban structure. Servius Tullius built a surrounding wall on the Etruscan pattern. He, incidentally, is probably to be identified with the Etruscan Mastarna, known to us from several sources including the Francois Tomb at Vulci, where he and other chiefs are depicted after conquering the Roman, Gnaeus Tarquinius.

The valley was cleared, and gradually became the meeting place for the villages built on the hills. And, with the construction of a great sewer, the Cloaca Maxima, the

valley, no longer used as a necropolis after the beginning of the sixth century BC, was drained and became the political centre of Rome – which had already become a Republic much earlier, in 510 BC.

It was the Etruscans who introduced the temple. One that is especially characteristic of the Etruscan style is the temple to Jupiter built on the Capitoline Hill.

Even after Rome had experienced the direct influence of Greek works of art, many aspects of the ancient Etruscan temple remained fundamental in buildings dedicated to Roman cults. These long-lasting influences helped to form the foundation from which a truly Roman art arose at the beginning of the second century BC, notably under Sulla.

But the position that art occupied in Roman society was still very inferior: the work of the artist was regarded as unworthy of a free man and merely as a mechanical activity more suited to the slave class. Gaius Fabius Pictor, who came from a noble family, was looked down on with contempt by Romans of his own social class because he had painted in the Temple of Salus, about 304 BC. Even later, when artists painted works to the greater glory of the Republic, showing the course of victorious campaigns against the enemy (the triumphal painting was from a very early date one of the most typical forms of Roman art) the majority of such artists were not Romans. The artist in Rome never attained the consideration and social status that he had enjoyed in Greece, even when the passion for collecting works of art became widespread among the upper classes. We know the names of hardly any Roman artists, and even the greatest masterpieces are generally anonymous. To us Roman art seems like some collective entity dedicated

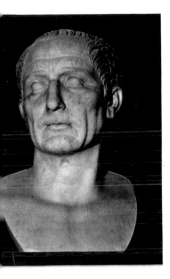

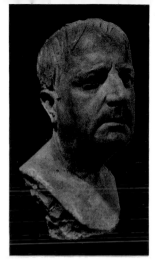

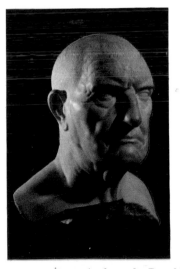

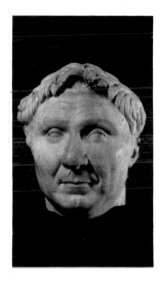

7 *Roman art : Portraits from the Republican era (Top, from left)*
Caesar. Museo Nazionale, Naples. Subject unknown. Museum of Fine
Arts, Boston. (Bottom, from left) Subject unknown. Metropolitan Museum
of Fine Arts, New York. Pompey. Ny Carlsberg Glyptotek, Copenhagen.

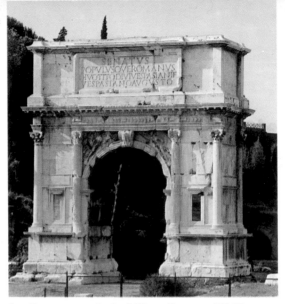

8 *Roman art : Arch of Titus, Rome. c AD 81.*

9 *Roman art : Arch of Augustus, Rimini. 27 BC.*

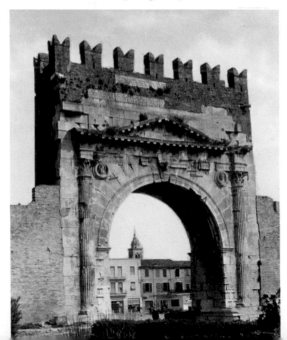

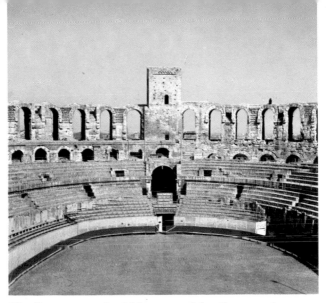

10 *Roman art : Amphitheatre at Arles, Provence. 1st century AD.*

11 *Roman art : Theatre at Merida, Spain. 18 BC.*

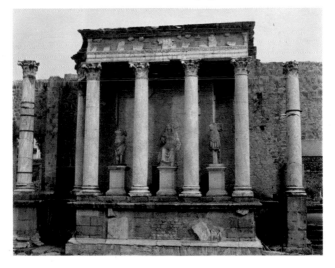

7 Roman art: *Portraits from the Republican era.* (Top, from left) *Caesar.* Museo Nazionale, Naples. *Subject unknown.* Museum of Fine Arts, Boston. (Bottom, from left) *Subject unknown.* Metropolitan Museum of Art, New York; Rogers Fund, 1912. *Pompey.* Ny Carlsberg Glyptotek, Copenhagen.

In the amount and quality of their portrait sculpture the Romans displayed a great appetite for and skill in recording with meticulous detail the faces of their contemporaries.

8–9 Roman art: (Top) *Arch of Titus*, Rome. *c.* AD 81. (Bottom) *Arch of Augustus*, Rimini. 27 BC.

The oldest triumphal arch to have come down to us is that of Augustus, erected at Rimini in 27 BC. The Arch of Titus was erected to celebrate his victorious campaign in Judaea.

10 Roman art: *Amphitheatre* at Arles, Provence. 1st century AD.

The amphitheatre was built over the ancient wall of the *castrum* of Caesar.

12 *Roman art : Amphitheatre at Pompeii, 79 BC.*

11 Roman art: *Theatre* at Merida, Spain. 18 BC.
The theatre at Merida (formerly Emerita Augusta) was built by
the consul Marcus Agrippa, son-in-law of Augustus, and was the
most luxurious of the Roman theatres in Spain. The stage was
reconstructed under Trajan and again under Hadrian in the 2nd
century AD.

12 Roman art: *Amphitheatre* at Pompeii. 79 BC.
The vast amphitheatre at Pompeii, built over a large square, is the
oldest Roman amphitheatre known; the original wooden building
was later replaced by one in stone.

13 Roman art: *Façade of the Theatre* at Aosta. 1st century AD.
The remains of the buttressed façade of the Roman theatre at
Aosta (formerly Augusta Praetoria), constructed with massive
square blocks, suggests something of the character of a fortress
town, which is what Augusta Praetoria was, being founded in
25 BC to defend the St Bernard route across the Alps.

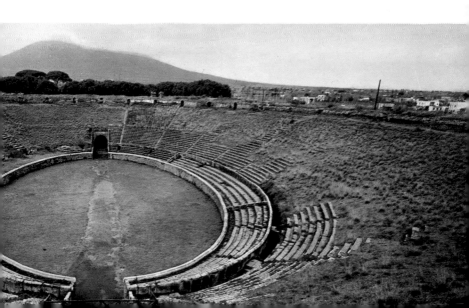

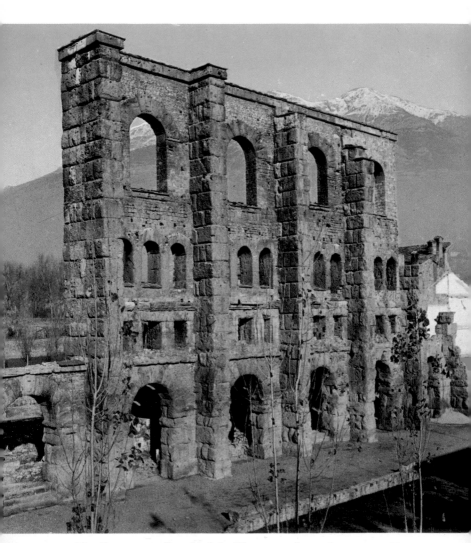

13 *Roman art : Façade of the Theatre at Aosta. 1st century AD.*

to the glory and commemoration of the State and its structure. None of this glory was ever reflected back on to the artist.

This is quite different from what Pliny tells us, speaking of Greece: 'Above all, the young men should learn the practice of the graphic arts, that is to say painting on wooden boards. And this must be regarded as the first step in the liberal arts, and has always been held in great honour insofar as it has always been practised by free citizens . . . and always been forbidden to those of servile condition. There is no record either in painting or in sculpture of any work by slaves.' And it was only on account of this Greek influence that the Emperor Hadrian, a Graecophil, did not himself scorn to practise the figurative arts.

It was during the period of the struggle against the colonies of Magna Graecia followed by their submission that Rome made direct contact with Hellenic art. In 212 BC the triumph of the consul Marcellus, conqueror of Syracuse, was commemorated with the most splendid works of art from that city. The cultural avant-garde openly praised Marcellus; he, on the other hand, was harshly rebuked by the conservatives. 'The Muse with winged step had been introduced amongst the proud and warlike people of Romulus.' Marcellus had inaugurated a new tradition that proved fundamental to the figurative culture of Rome. Three years later, the sack of Taranto yielded even more splendid treasures, among them the Hercules of Lisippus, which was placed on the Capitol. During the first twenty years of the second century BC, the conquests of Asia brought the Roman environment into direct contact with some of the great centres of Hellenism. The artistic sway of Hellenism now extended to Rome, and the conquest

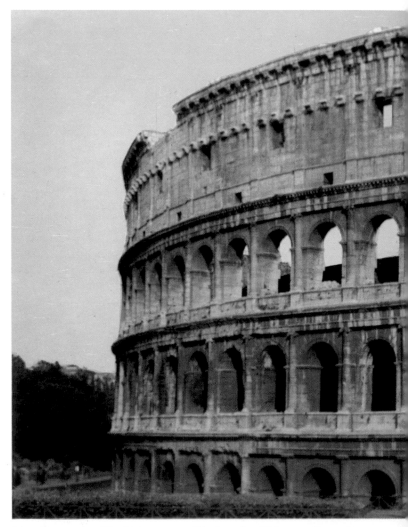

14 *Roman art : The Colosseum or Flavian Amphitheatre, Rome. 1st century AD.*

14 Roman art: *The Colosseum or Flavian Amphitheatre*, Rome.
1st century AD.
The most famous monument of the whole Flavian period is the
Colosseum, the gigantic amphitheatre begun by the Emperor
Vespasian and inaugurated by his son Titus in the year AD 80.

15 Roman art: *Pont du Gard*, near Nîmes. End of 1st century BC.
This aqueduct, built over the valley of the Gard by Agrippa, also
served as a bridge capable of taking chariots as well as men. As
in other examples of Roman aqueducts, the fusion of elegance and
praticability is to be admired.

15

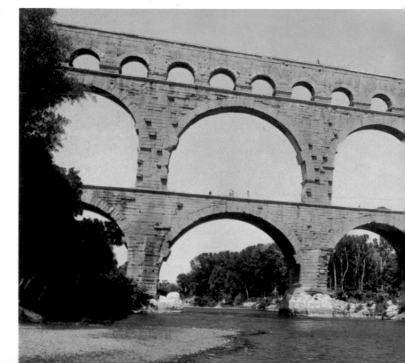

16 Roman art: *Sacred Way and Arch of Titus*, Rome.
Processions along the Sacred Way set off from the heights of the
Velia and then climbed up to the Temple of Jupiter on the Capitol.

17 Roman art: *Aqueduct* at Segovia, Spain. 1st century AD.
Trajan promoted the building of numerous public works through-
out Italy and the provinces, among them this architecturally
daring aqueduct at Segovia with its double tier of arches.

18 Roman art: *Maison Carrée*, Nîmes. 19 BC.
The Maison Carrée is one of the finest surviving examples of
Roman temple architecture: its design follows the traditional
frontal plan, Etruscan in origin, of colonnaded porch and cella.

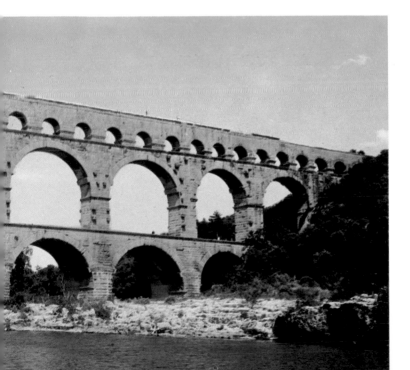

16 *Roman art : Sacred Way and Arch of Titus, Rome.*

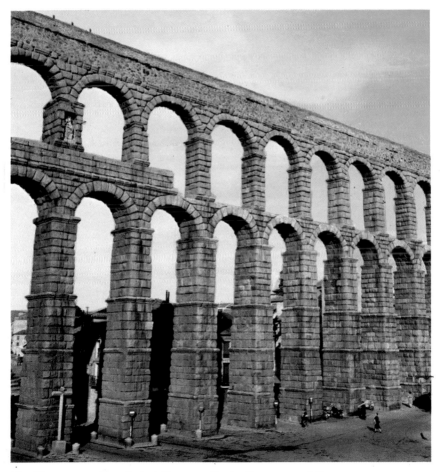

17 *Roman art : Aqueduct at Segovia, Spain. 1st century AD.*

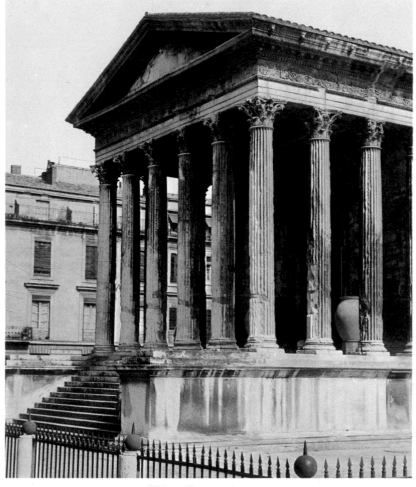

18 *Roman art : Maison Carrée, Nîmes.* **19 BC.**

of Greece was to complete the work. As the famous lines of Horace say: *Graecia capta ferum victorem cepit et artes intulit agresti Latio* (On being captured Greece took her coarse victor in hand and introduced the arts to uncivilized Latium). Cato might still fanatically fight his rear-guard action: 'There are far too many I hear admiring and praising the works of Corinth and Athens, while they laugh at the clay images of the Romans . . .'; but the more progressive Romans, dominated by the Philhellenic circle of the Scipioni, did indeed laugh at the old terracotta statues and at the ancient Etruscan ones and their provincial imitations. They all seemed impossibly 'old'. Roman artistic society had grown up, and Rome herself was preparing to change her appearance. The second century BC was the epoch of the great urban transformation. It was then that the first monumental buildings arose, the new bridges (the Milvian bridge dates from 109 BC), and the new aqueducts. The Forum gradually lost the aspect of a rural market and acquired that of a modern business city. The basilicas (the Porcia, the Aemilia, the Sempronia) became the centres of economic life and furthered the disappearance of the old *tabernae*, the shops that had jostled each other on the square.

Greek influence was particularly noticeable in sculpture, in the portrait statues, those effigies erected in the Forum to honour worthy citizens – a fairly ancient tradition that had taken root in the second century BC. Pliny assures us that beside the more austere and severe statues depicted in togas or armour, according to whether the citizen was honoured for peaceful or martial deeds, could be seen Achillean statues portrayed in all their heroic nudity following the Greek fashion. But it was during the dictatorship of Sulla (85–78 BC) that Roman art made real

and sudden progress, especially in the field of architecture, the form of art dearest to the Roman spirit. (It was not for nothing, indeed, that the architect enjoyed the highest consideration of all artists, and often proudly signed his own works.)

The commemorative inscription on the bridge over the Tagus at Alcantara says that 'this bridge built by the noble Caius Julius Lacer with divine art will last for ever in the centuries to come'. Although it is true that Lacer lived during the Trajan epoch when art was regarded more highly than in the Republican era, we do not find anything in similar spirit recorded about a painting or sculpture. The practical spirit of the Romans, once it had infused the figurative arts, acted as an indestructible foundation for all artistic activity, even during those

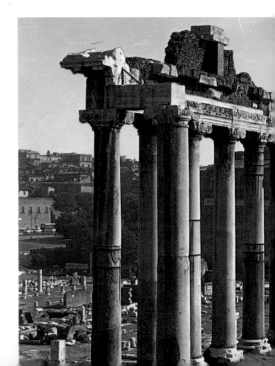

19 *Roman art :*
Colonnade of the
Temple of Saturn,
Rome.

periods most subject to Hellenistic influence. It is not mere chance that the only treatise written by a Roman on the figurative arts to come down to us is the *De Architectura* of Vitruvius.

The temple of Fortuna Virilis at Rome, the Temple of Hercules at Cori and the Temple of Jupiter at Terracina all date from the period of Sulla. In them Greek and Etruscan elements have been merged to give a new scenographic vision. It became customary to place the temple, which was raised on a high base, at the end of a square, so enclosing it on that side. With the new building techniques of the Romans a more complex and articulated architecture became possible. From *opus quadratum*, using squared tufa blocks, the architects moved on to concrete – a most important innovation. This was at first faced with frag-

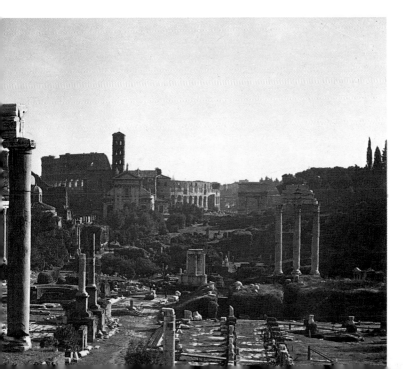

20 *Roman art : Stucco panel from Stabiae. Museo Archeologico Nazionale, Naples.*

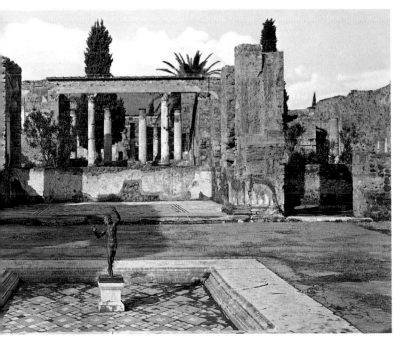

21 *Roman art : Atrium of the Villa of the Faun, Pompeii. 2nd century BC.*

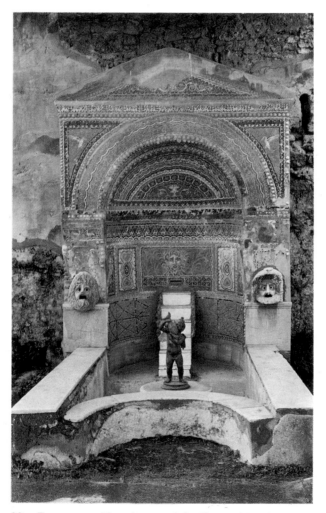

22 *Roman art : Nymphaeum of the House of La Granda
Fontana, Pompeii.*

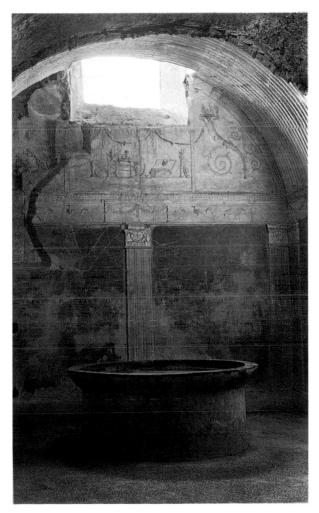

23 *Roman art : Tepidarium of the Baths at Stabiae.*
2nd century BC.

19 Roman art: *Colonnade of the Temple of Saturn*, Rome.
At the foot of the Capitol, a temple was erected between 501–493 BC, which was dedicated to the god Saturn, who, according to tradition, had reigned over Latium during the mythical Golden Age. This temple was restored several times during the Republican period. It was reconstructed in 42 BC by General Munatius Plancus; finally in the 4th century AD it was again reorganized.

20 Roman art: *Stucco panel* from Stabiae, Museo Archeologico Nazionale, Naples.
The figure of an athlete in repose is the theme of this beautiful stucco panel. The rhythmical articulation of the body is expressed with exquisite harmony, and the elegant canopy is supported by slender columns that also frame the figure of the youth.

21 Roman art: *Atrium of the Villa of the Faun*, Pompeii. 2nd century BC.
Much of Pompeii, Herculaneum and Stabiae has been spared exposure to the intervening centuries after it was buried under a severe eruption of Vesuvius in AD 79. Today men may again admire the treasures of those cities.

24

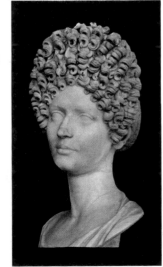

22　Roman art: *Nymphaeum of the House of La Granda Fontana, Pompeii.*
This fountain, in the shape of a niche, is covered with precious mosaics of a dazzling colour; a villa at Pompeii is named after it.

23　Roman art: *Tepidarium of the Baths of Stabiae.* 2nd century BC. The Stabian Baths, built during the period of the Samnite dominion, were restored several times. The *tepidarium* was a room in which a moderate temperature was maintained by means of a current of warm air conveyed either under the floor or along the walls.

24–5　Roman art: Portraits from the first years of the Empire. (From left) *Scipio Africanus.* Museo Archeologico Nazionale, Naples. *Lady of the Flavian epoch.* Musei Capitolini, Rome. *Augustus.* Musei Capitolini, Rome. *Octavia.* Louvre, Paris. Under the influence of Hellenistic art, the Imperial Roman sculptors tended in their free-standing work to pursue an idealizing manner, but for their portrait heads they developed a more meticulous realism.

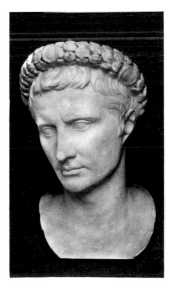

25

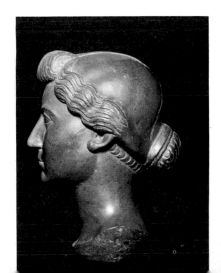

ments and then came *opus reticulatum*, a regular scheme of squares or triangular stones. The new concrete was particularly effective because of its plasticity and economy. In 55 BC Pompey built the first permanent theatre and thereby broke an age-old veto, dictated by prejudice, which had considered theatrical spectacles as useless, even dangerous to public morality. The erection of the Temple of Venus Genitrix on the summit of the auditorium certainly looks like a compromise attempt to render the event more acceptable to the conservatives.

In the course of his few years in power, Caesar, with his law *de urbe augenda* (concerning the increase of the city) had posed the problem of how to reconstruct the whole of the centre of Rome on a more monumental scale. And it is to him that we owe the first of the Imperial Fora (Forum Iulii), situated next to the Republican one and dominated in the background by the temple of Venus Genitrix.

In the field of sculpture, the most widespread form was the portrait with the old underlying basis of realism. At times, especially in the funerary reliefs, this realistic representation assumed analytical, naturalistic tones. The directness of the approach in fact suggests possible connections with the idea of the wax mask that was formerly obtained from the face of a dead person and then kept by his or her relatives as a memorial.

The tradition of sponsoring celebratory works to commemorate, for example, the exploits of a victorious legion, remained alive. The history of Rome during the first century BC was a vital theme in sculpture. The continuous frieze in the Basilica Aemilia (dating, perhaps, from the period of the restoration and enlargement of the basilica, 53–35 BC) relates the primitive history of Rome in the

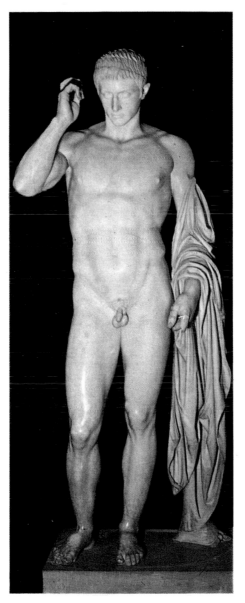

26 *Roman art : Statue of Augustus. 1st century BC. Musée du Louvre, Paris.*

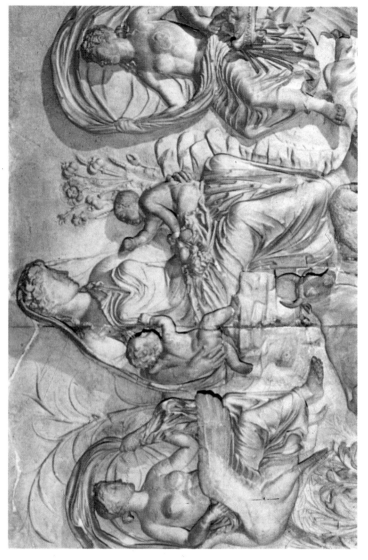

27 *Roman art: Relief from the Ara Pacis, Rome. 13–9 BC.*

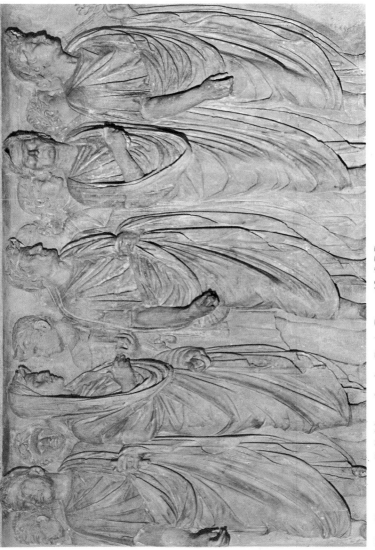

28 *Roman art: Relief from the Ara Pacis, Rome. 13–9 BC.*

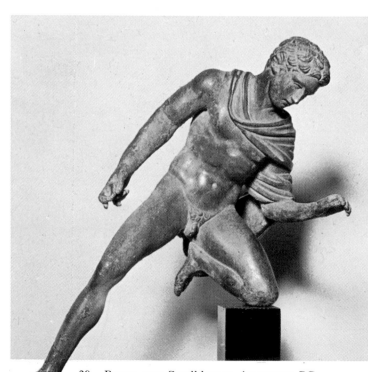

29 *Roman art : Small bronze. 1st century BC–*
1st century AD. British Museum, London.

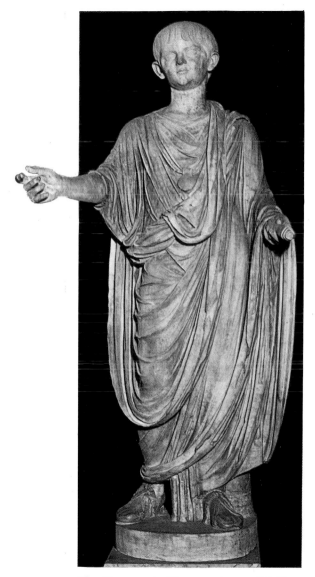

30 *Roman art : Nero as a boy. c AD 40.*
Musée du Louvre, Paris.

26 Roman art: *Statue of Augustus*. 1st century BC. Musée du Louvre, Paris.

The Emperor Augustus is portrayed naked in the characteristic manner of Greek heroic statuary; the author of this work, Kleomenes, was himself Greek.

27–8 Roman art: *Reliefs from the Ara Pacis*, Rome. 13–9 BC.

The Ara Pacis, which was erected in the Campus Martius, is the most important monument of the Augustan age, whose exalted religious and civil ideals it illustrates. On the eastern side, to the left of the door, is the relief of Saturnia Tellus (27) personified by a young matron who is sitting between a nymph and a nereid, symbols, respectively, of the rivers and seas of Italy. Combining with these symbolic figures there winds a majestic procession (28) for the inauguration of the altar, in which Augustus, Tiberius and other important members of the Imperial family were featured as well as lictors, senators and priests.

29 Roman art: *Small bronze*. 1st century BC – 1st century AD. British Museum, London.

This small bronze of a young man must at one time have formed part of a group of figures, perhaps depicting a youth struggling with a wild animal.

30 Roman art: *Nero as a boy. c* AD 40. Musée du Louvre, Paris.

The preference for accurate, realistic portraiture gained considerable ground in the reign of Claudius (AD 41–54), whom Nero followed as emperor.

31 Roman art: *Relief on the Arch of Titus*, Rome. End of the 1st century AD.

The quadriga that carried the victorious Emperor in triumph is depicted in this relief adorning the inside of the Arch of Titus. The placing of the horses along an oblique line and the frontal position of the chariot give the composition breadth and movement.

31 *Roman art : Relief on the Arch of Titus, Rome. End of 1st century AD).*

eclectic style of the time, displaying classical and realistic modes side by side.

As the Greek influence in Roman art increased, so sculpture and painting assumed new, important dimensions and took on a new decorative function. For example, Sulla owned a Hercules of Lisippus – which in itself demonstrates the great progress that had been made since the time when Camillus was accused of decorating his door with bronze knockers taken from the booty of Veii. Now, the cultivated and wealthy classes of Rome turned their attention to neo-attic copies of famous Greek originals and used these to decorate their atria, gardens, libraries and other main rooms. Even the paintings in private houses were used as background decoration – as may be seen from the wall paintings of Pompeii. At the time of Caesar's death, the cultural situation that had prevailed in the first days of the Republic was reversed: Rome had become the centre of attraction for artists working in the territories subject to her, and, furthermore, the centre from which the most significant artistic ideas were elaborated and sent forth.

FROM AUGUSTUS TO THE LATE EMPIRE

A new phase of Hellenism, which opened in Rome from the beginning of the first century BC, soon became the most lively and original movement of the time. The description 'Roman Art' is in modern times applied to what was in fact an amalgam of Etruscan, Italic and, above all, Hellenistic elements that were absorbed and reworked as Roman culture adapted them to her own national demands. But perhaps it would be closer to the truth if we were to call the art of the period, at least up

to the Late Empire, by the term Hellenistic-Roman art. Hellenistic characteristics are deep-rooted in the most significant monument of the Augustan epoch, the one, more than any other, that represented its ideals: the Ara Pacis (Altar of Augustan Peace), dedicated in the Campus Martius on 30 January 9 BC. The figurative decoration of the altar has been almost entirely lost; there remain only a few fragments of the frieze that surrounded the altar table, representing the annual sacrifice of the suovetaurilia (This was celebrated in front of the altar, and was a purificatory sacrifice consisting of a swine, a sheep and a bull.) The altar is surrounded by a wall screen containing a rich decoration. On the inside walls there is a large frieze with garlands and ox-skulls, alluding to the ritual sacrifices. On the outside a solemn procession is depicted, commemorating the one that took place on 4 July 13 BC, the day the altar was consecrated. This work recalls the Panathenaic frieze of the Parthenon, but here the participants are developed with far more realism. The one is a typical representation of the Athens of Pericles, the other seeks to identify in precise detail the Imperial family and the magistrates, senators and other officials of Rome. In the end, though, both express the same faith in a victorious and fortunate humanity – the same illusion of an uninterrupted progress to eternity.

On the other hand, there is nothing more splendidly Hellenistic than the acanthus spirals that cover the lower half of the sacred wall and which twist around the four external walls; this was a design of great decorative effect that was to be widely imitated in the Middle Ages. And even the Parthenon-like solemnity of the panel on which Aeneas sacrifices to the Penates, on the right-hand side of the front façade, seems to dissolve into a rather bucolic,

perhaps almost Alexandrian scene. Moreover, nothing is more Alexandrian than the most famous of the reliefs on the altar (the most famous by virtue of its academic flavour, but not the most beautiful) which is set on the back wall of the screens and so corresponds with the relief of Aeneas. This shows the land pacified and made prosperous and happy by the *Pax Augusta*. The animals, the vegetation, the sea, the soft plumage of the swan, the buxom feminine figure are all part of the Hellenistic repertoire, even if the soft Alexandrian modelling has been interpreted here and there with a certain frigidity. There are four reliefs on the short east and west exterior walls and all are symbolic – in contrast to the 'historical' reportage that is unfolded on the other, longer walls.

Around the Ara Pacis are to be found the works promoted by Augustus and his ministers, Maecenas and Agrippa, that gave Rome a new monumental appearance. '*Restitutor aedium sacrarum et operum publicorum*, Augustus could indeed be proud that he had transformed the Rome of terracotta and bricks into the Rome of marble' (Becatti). The main episodes of the building programme of the Principate were the completion of Caesar's Forum, the construction of the Forum of Augustus, and the building of the Pantheon. The latter was destroyed by fire and was later rebuilt under Hadrian. Under the vast cupola of this temple, dedicated to the seven planetary gods, a new, all-embracing notion of cosmic unity is apparent: indeed, we are a long way away from the 'human scale' of the architecture and sculpture of the Parthenon.

The classicism dominant in official Augustan sculpture and also clearly visible in the idealized youthfulness of the many portraits of the Emperor, left its mark on succeeding periods. The realistic trend, at first under

32 *Roman art : Trajan's Column, Rome. AD 113.*

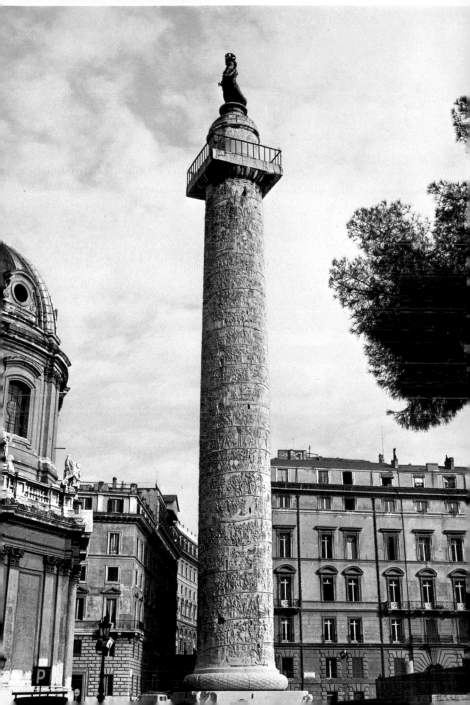

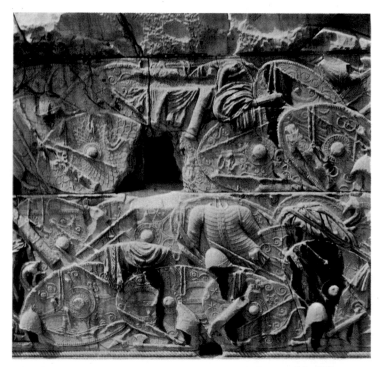

33 *Roman art : Detail from Trajan's Column, Rome. AD 113.*

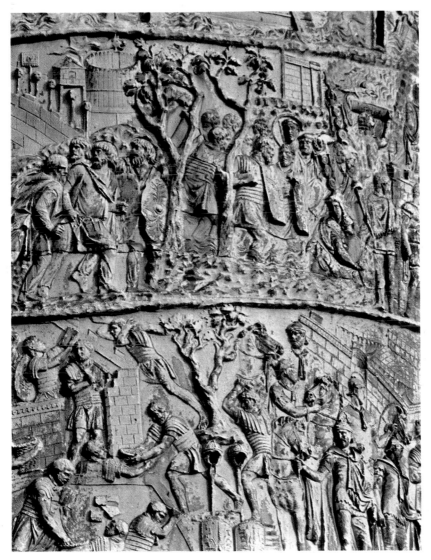

34 *Roman art : Detail from Trajan's Column, Rome. AD 113.*

32 Roman art: *Trajan's Column*, Rome. AD 113.
The Roman Empire reached its greatest extent during the reign
of Trajan (AD 98–117), who ruled over territories stretching from
the Atlantic coast to the Balkans, from Great Britain to Arabia,
Mesopotamia, Assyria and Armenia. The column, erected by
Apollodoros of Damascus in the centre of the Trajan Forum, is a
memorial to Trajan's two victorious campaigns in Dacia. A
continuous spiral band of reliefs winds around the column for a
total length of some 615 feet.

33–4 Roman art: *Details from Trajan's Column,* Rome. AD 113.
The importance of Trajan's Column is due not only to the in-
ventive manner in which the reliefs have been arranged, and their
considerable historical and documentary value, but above all to
the very high quality of the sculpture, the handling of perspective
and detail that reveal the guiding hand of a master of exceptional
skill.

35 Roman art: *Detail of the Aldobrandini Wedding.* Biblioteca
Vaticana, Rome.
The fresco, known as the *Aldobrandini Wedding*, that was found
in a villa on the Esquiline and depicts various nuptial scenes, is a
precious example of Roman painting discovered in Rome itself.
Strange as it may sound, the capital of the Empire has not provided
many examples of Roman painting; these have come, instead,
from Pompeii, Herculaneum and Stabiae.

36 Roman art: *Girl pouring scent.* Fresco from the Villa Far-
nesina. Museo Nazionale Romano, Rome.
The simple and precious grace of this girl, sketched with a few
light strokes against a neutral background, reveals the Greek
inspiration of the painter; and is reminiscent of the only examples
of painting known to us from Greece itself – those used to decorate
pottery.

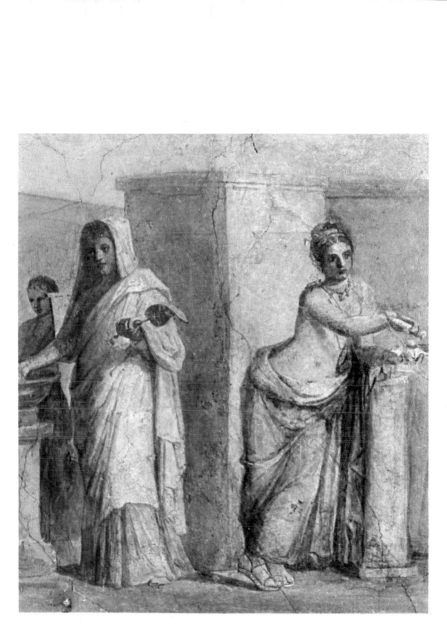

35 *Roman art : The Aldobrandini Wedding (detail). Biblioteca Vaticana, Rome.*

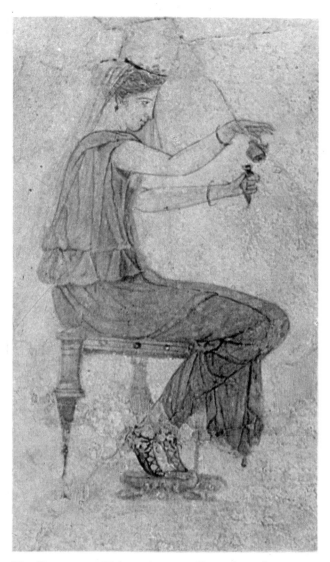

36 *Roman art : Girl pouring scent. Fresco from the Villa Farnesina. Museo Nazionale Romano, Rome.*

Claudius, and then in Nero's time, gathered strength once more, but now remained confined to a less official sphere, to a more private and popular kind of art. Thus, beside the famous portrait of Norbanus Sorex or that of the Pompeian man and wife – which almost seems to foreshadow the Egyptian portraits of Fayum – are to found a body of 'minor' sculptures dealing with aspects of daily life and the occupations of merchants and shopkeepers as depicted on their various signs.

The realistic current also penetrated Imperial art during the reign of the Flavians (Vespasian, Titus and Domitian) from AD 69–96. The portraitist would now take his time to carve the wrinkles on the lean face of Vespasian, or to veil with a light shadow the fleshy face of some matron of noble lineage. The representations on the triumphal arch erected by the Senate in honour of Titus, the conqueror of Judaea (AD 70), reveal a style full of movement and narrative ideas, sometimes dramatic and certainly very far from the classical composure of the Augustan reliefs. Now that the neutral background had been eliminated, artists sought to create an illusion of free space in which their action could take place. The background seemed to open out and receive the moving people. The action being narrated became truer and more real in a setting that exploited the idea of depth. In the field of architecture, in the second half of the first century BC, two grandiose monuments arose: the huge Golden House that Nero had built – possibly in imitation of the tastes of the great Oriental princes; and the Flavian Amphitheatre or Colosseum. The amphitheatre was a Roman invention obtained by doubling the measurements of the Greek theatre. With this huge building, Nero solved the problem of presenting circus spectacles,

which had been conceived as entertainment for the masses. A severe eruption of Vesuvius in AD 79 buried Pompeii, Herculaneum and Stabiae. As well as preserving fine examples of Roman town-planning and domestic architecture, the eruption has also enabled us to follow the complete evolution of painting (even if it was more provincial in style than the art that must have flourished in the capital) during the first century BC and the first century AD – up to the moment when the lava of the volcano put an end for ever to the life of the three towns. The painting that adorned Roman houses was decorative painting. It had the same ornamental function as the Greek statues that were so sought after at the time – whether in the form of copies or originals.

The decorative style at Pompeii developed more or less independently, and it is customary now to distinguish four main styles of Pompeian painting. The oldest, dating from the second century BC, is the so-called Incrustation Style, and is composed of simple panels of coloured stucco. The Second Style (Architectural Perspective) dates from the beginning of the first century BC and is clearly of Hellenistic derivation – as was the majority of Roman painting. The approach to wall painting, with its imitation architectural features, became more complex. The intention was to expand the real space on the wall in an illusionistic manner in the same way as theatre scenery is treated. The Third Style overlapped with the end of the second. It was more sober and tended to produce decoration without depth. Paintings, almost like miniatures, stood out against a unified background of a dark colour: 'in generally warm-coloured tones such as red, yellow, shiny black, and soft ones like greenish-blue'. And 'a few light brush strokes . . .

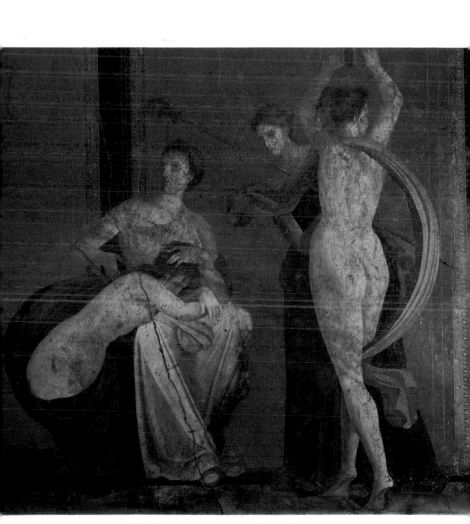

37 *Roman art : The flagellation of the bride-to-be and the bacchante.*
Detail from a fresco in the Villa of the Mysteries, Pompeii. 1st century BC.

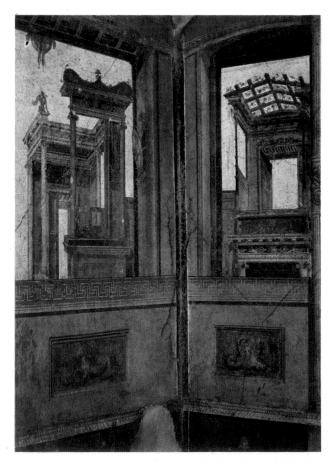

38 *Roman art : Architectural fantasies in a fresco from the
House of the Vettii, Pompeii.*

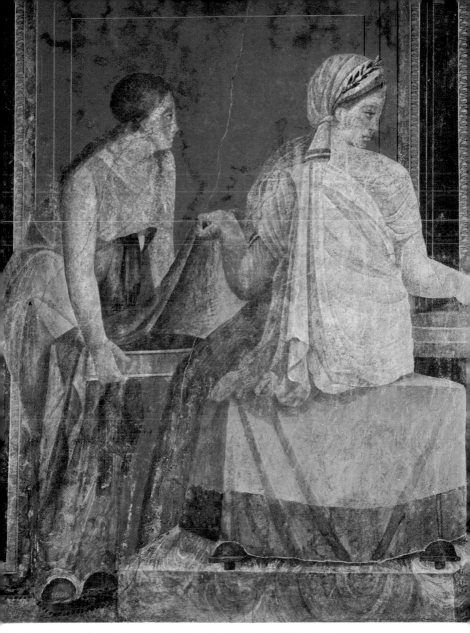

9 *Roman art : Scene from the Dionysian ritual in the Villa of the Mysteries, Pompeii. 1st century BC.*

37 Roman art: *The flagellation of the bride-to-be and the bacch-ante*. Detail from a fresco in the Villa of the Mysteries, Pompeii. 1st century BC.

The mystic cult of Dionysus, which had been imported from the East, had already become so widespread as to have provoked the intervention of the Senate in 186 BC. Its condemnation could not have been very effective because, only two centuries later, a noble lady of Pompeii was able to have a room of her villa, the Villa of the Mysteries, decorated with a cycle of frescoes portraying a Dionysian pre-nuptial ceremony.

38 Roman art: *Architectural fantasies* in a fresco from the House of the Vettii, Pompeii.

This detail shows two of the airy, baroque creations that artists working in the Fourth Style of Pompeian wall painting devised to make the rooms of their clients seem larger and more elegant.

39 Roman art: *Scene from the Dionysian ritual* in the Villa of the Mysteries, Pompeii. 1st century BC.

In this detail of a Dionysian frieze (see also illustration 37) a priestess and an attendant carry out a rite of purification.

40 Roman art: *Spring*. Painting from Stabiae. Museo Archeo-logico Nazionale, Naples.

Against a bright green background a girl, since identified with Spring, moves with a light step holding a basket of flowers.

41 Roman art: *The actor-king*. Fresco from Herculaneum. Museo Archeologico Nazionale, Naples (top). *Pentheus torn by bacchantes*. Fresco from the House of the Vettii at Pompeii (bottom).

Both these compositions are precisely organized and vigorously executed: in the first the actor-king is brought into special prominence through the whiteness of his clothing, his proud gesture and noble expression; while the painting of Pentheus, inpired by the famous mythological story, is filled with drama and movement.

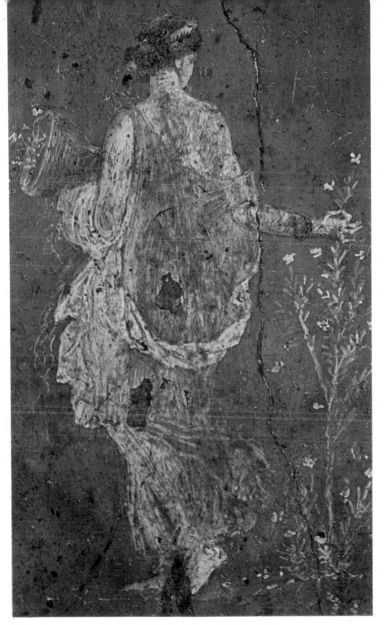

40 *Roman art : Spring. Painting from Stabiae, Museo
Archeologico Nazionale, Naples.*

41 *Roman art : The actor-king. Fresco from*
Herculaneum. Museo Archeologico Nazionale, Naples
(top). Pentheus torn by bacchantes, Fresco from the
House of the Vettii, Pompeii (bottom).

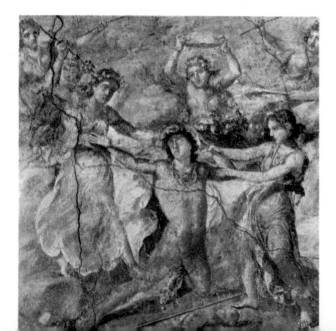

tiny delicious linear or floral decorations . . . compositions of figures, landscapes or even actual paintings' (Bianchi Bandinelli).

From the Second Style developed the exuberant fantasy and decorative richness of the Fourth Style; here the architectonic motifs present in the earlier style became more accentuated. The Hellenistic derivation of all these decorative styles is fairly obvious, but not all of them were to have the same success. 'Once the greater consistency of the Third Style is recognized, it is not surprising that its elements dominated the decorative forms of the second century AD, after the phantasmagoria of walls in the Fourth style had been exhausted by the end of the previous century. During the era of Hadrian these forms became more sober and linear, and were in danger of becoming altogether frozen and static. Then, during the Antonine age, they began to grow warmer, and there was a certain renewal of the perspective elements . . . until the advent of slender architectural forms – from which after AD 180 all trace of illusionism had disappeared, and everything had become completely schematic – gave birth to a linear style in red and green on a white background. From then on this style, with remarkable uniformity, was to cover the walls and vaults of houses and funerary cubicles, including those of the Christian catacombs' (Bianchi Bandinelli).

The subjects of the themes illustrated were generally drawn from Greek myths or from the contemporary period; others were taken from the world of religion (as in the famous cycle in the Villa of the Mysteries). Paintings in the popular style (shop signs, pictures of games and festivals) are a study in themselves, but there too the connection with the Hellenistic world can be seen in the use of a 'summary' technique. This taste for 'summary'

painting is characterized by a use of large, impressionistic blobs of colour; this and the vigorous interplay of light and shade are a feature of numerous still-lifes and landscapes (the latter being a favourite theme of Roman painting). The landscapes, either imaginary, idyllic or real, endeavour to present, say, a garden by breaking down the enclosed space of a room and implanting instead in the observer's mind the notion of being out in the open air.

The era of Trajan (AD 98–117) played a very important part in the course of Roman art. The new Forum that the Emperor built (designed, it appears, by Apollodorus of Damascus) contained a column erected to celebrate the Dacian campaigns (AD 101–2 and 105–6). This was a new and original type of monument, the heir to the commemorative columns erected in the Forum in honour of important persons, and to the historical and triumphal paintings. The relief on the Trajan column unfolds like a spiral parchment roll around the shaft for about six hundred and fifteen feet. The story is developed continuously without interruptions and has a rapid, compelling rhythm. This is no longer a simple chronicle but a great and moving epic poem. There is hardly any slackening of tension in the depiction of the battles, the exhausting marches, the fording of rivers, the attacks on cities, the woods, the plains, the fortifications and the camps. For the first time there appears a new feeling of human compassion for the despair of the conquered, the suffering of the wounded and the drama of the prisoners. The immediate, dramatic and relentless rhythm of these reliefs, which Bianchi Bandinelli has rightly compared to Donatello's sculptures in St Anthony's, Padua, introduces a new dimension into the art of the period and, perhaps,

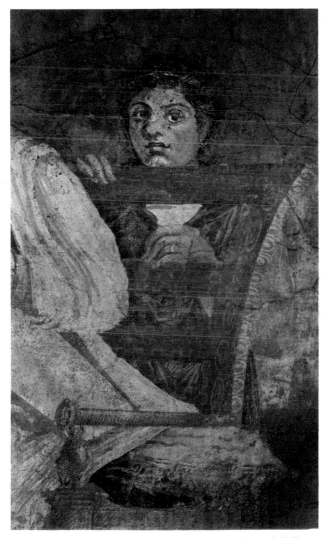

42 *Roman art : Detail of a fresco from a villa at Boscoreale, near Pompeii. Middle of the 1st century BC. Metropolitan Museum of Art, New York.*

43 *Roman art : Street musicians. Detail of a mosaic signed by Dioscurides of Samos, from Cicero's Villa at Pompeii. Museo Archeologico Nazionale, Naples.*

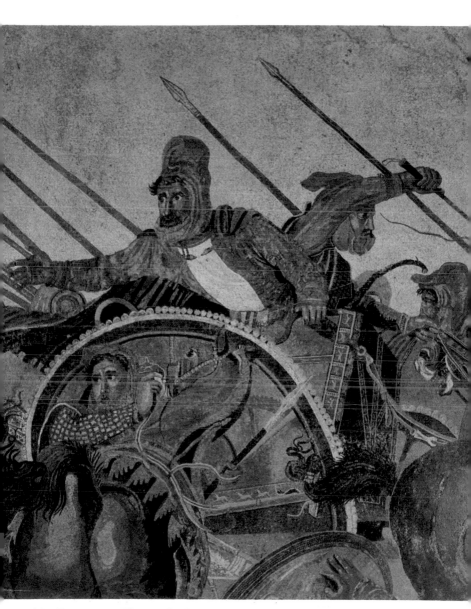

44 *Roman art : The Battle of Issus (detail). Museo Archeologico Nazionale,*
Naples.

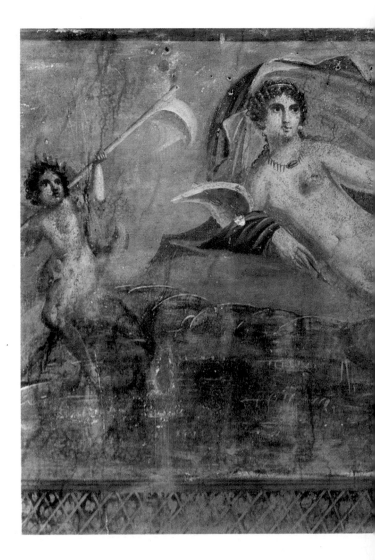

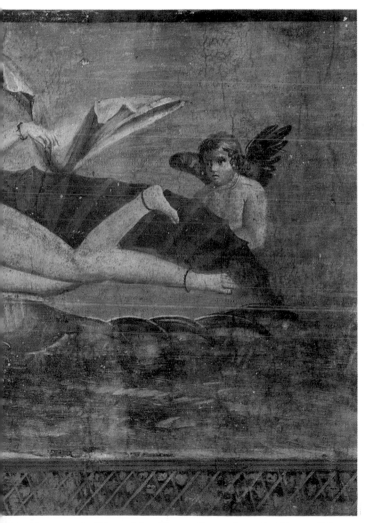

45 *Roman art : The goddess Venus. Fresco from the House of Venus,
Pompeii.*

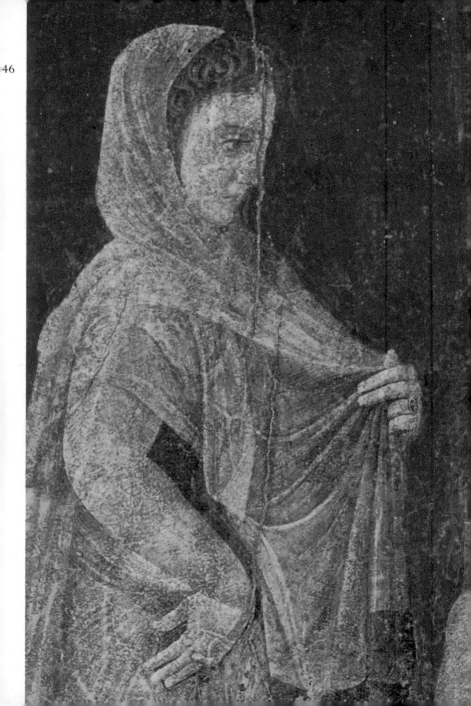

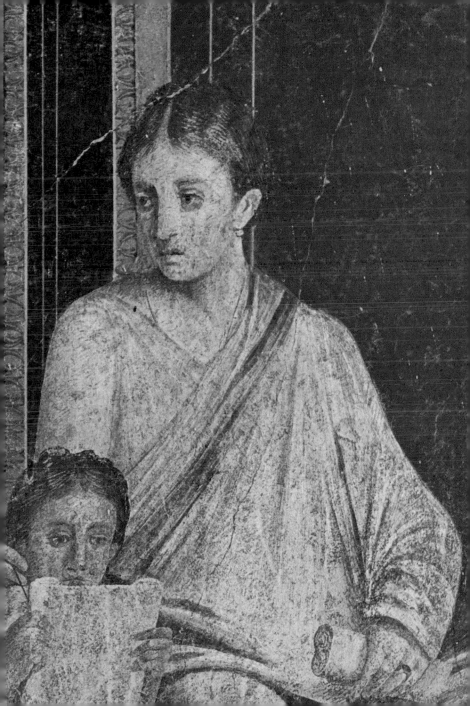

42 Roman art: *Detail of a fresco*, from a villa at Boscoreale, near Pompeii. Middle of 1st century BC. Metropolitan Museum of Art, New York; Rogers Fund 1903.

The frescoes of Boscoreale are divided into two cycles: the first is dominated by architectonic and landscape motifs, and the second by human figures.

43 Roman art: *Street musicians*, from a mosaic signed by Dioscurides of Samos, from Cicero's Villa at Pompeii. Museo Archeologico Nazionale, Naples.

These lively images reflect the popular taste for the everyday in art, and are executed with vigour and realism.

44 Roman art: *The Battle of Issus* (detail). Museo Archeologico Nazionale, Naples.

The subject of this precious mosaic, which decorates the House of the Faun at Pompeii, is the famous battle of Issus won by Alexander the Great in 333 BC. The technique is extremely fine and includes an effective use of chiaroscuro.

45 Roman art: *The goddess Venus*. Fresco from the House of Venus, Pompeii.

Venus, the protectress of Pompeii, is supreme in the wall painting of that city. Here she lies stretched out on an enormous shell, an obvious allusion to her marine origins (the name of her Greek predecessor, Aphrodite, means 'born of the foam').

46 Roman art: *The Initiation* (detail). Fresco in the Villa of the Mysteries, Pompeii. 1st century BC.

A young woman stands by an open door in the wall and listens to a boy reading aloud from a sacred papyrus containing a Dionysian ritual.

47 Roman art: *Still life*. Fresco from Herculaneum (top). *Cave canem*, mosaic from Pompeii. Museo Archeologico Nazionale, Naples (bottom).

Still lifes feature prominently in Pompeian wall painting; compositions of fruit, birds and fish were among the most popular motifs of the fresco painters.

47 *Roman art : Still life. Fresco from Herculaneum (top). Cave canem. Mosaic from Pompeii (bottom). Museo Archeologico Nazionale, Naples.*

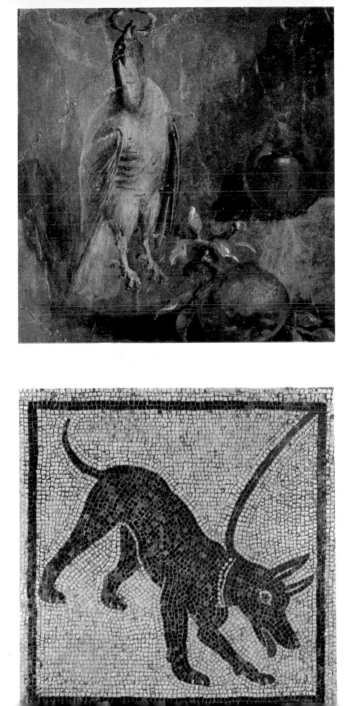

represents the noblest expression of Roman art. Possibly there still lingers 'an echo of the sculptures of Pergamum or Rhodes' but the treatment and the language – energetic and passionate, but now in a human and real sense, no longer heroic or mythological like the Pergamene altars – were already moving away from Hellenism, even if they had not yet become completely differentiated in what eventually became the style of Late Antiquity.

The unknown master of the Trajan Column can probably be credited with the remains of the 'Great Trajanic Frieze' that formerly decorated the Trajan Forum – and also commemorated the victories of the Emperor over the Dacians. This frieze was inserted at a later date into the Arch of Constantine, a veritable hotchpotch of sculptures from various periods. The Trajan Column served as the model for another column erected between AD 108–93 in commemoration of the victories of Marcus Aurelius over the Marcomanni and the Sarmatians. In fact, after the Hadrianic period and the Hellenistic restoration work of that most Graecophil emperor, this column helped to instigate a steady movement away from the artistic values of Hellenism. The two columns, the Marcus and the Trajan, are similar not only in their general structure but also in the iconographic repertoire and in the realistic settings. However, the style of the Marcus Column is different: the sculptures are tormented and harsh, rich in shadowing that gives the figures dramatic depth and brings the story vigorously to life. In short, it was an 'expressionist' style.

These same powerful and dramatic tendencies, producing distorted figures and intensely expressive faces, are to be found in numerous sarcophagi of the day. Among the more famous of these is the Ludovisi Sarcophagus, on

48 *Roman art : Harbour scene. Fresco from Pompeii. Museo Archeologico Nazionale, Naples.*

48 Roman art: *Harbour scene*. Fresco from Pompeii. Museo Archeologico Nazionale, Naples.

Landscape painting was a very popular theme in the painting of Campania. The use of a black background makes a superb decorative effect.

49 Roman art: *Portrait of Terentius Neo and his wife* (top). *Portrait of a girl*, from Pompeii (bottom). Museo Archeologico Nazionale, Naples.

The personalities of the couple – the husband more uncouth and instinctive, the wife shrewder and more prudent – make this vivacious painting a masterpiece of Pompeian portraiture. Note the similarities in the poses of the women.

50–1 Romano-Egyptian art: *Portrait of a man*, from Fayum. *Portrait of a young girl*, from Memphis. Paintings on wood. 1st century AD. Musée du Louvre, Paris.

Egypt became Romanized after its conquest by Augustus, but the art that flourished there could not be defined as Roman. Although the influence of the invader was felt, art in Roman Egypt grew from a double tradition of Hellenism and Pharaonic art.

52 Roman art: *Part of the Maritime Theatre* in Hadrian's Villa, Tivoli. 2nd century AD.

The villa, built by Hadrian at Tivoli, was ingeniously constructed in a harmonious blend of buildings and natural elements.

53 Roman art: *Interior of the Pantheon*, Rome. 1st century BC – 2nd century AD.

The Pantheon is regarded as one of the greatest monuments of antiquity. The massive interior dome was intended to echo the great celestial sphere and has a diameter at its base of 124 feet.

54 Roman art: *Part of the Forum* at Jerash. 2nd – 3rd century AD. The oval Forum of Jerash was linked at one end by a road passing through the main part of the city; it served as a station and exchange market for the caravans. The diameters of the Forum are 262 x 164 feet.

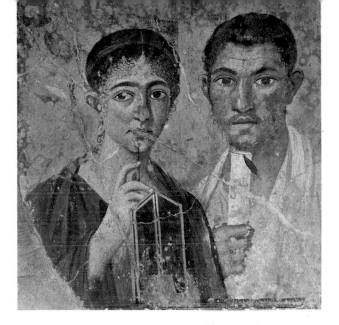

49 Roman art : Portrait of Terentius Neo and his wife
(top). Portrait of a girl, from Pompeii (bottom). Museo
Archeologico Nazionale, Naples.

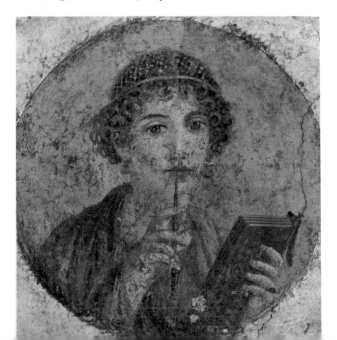

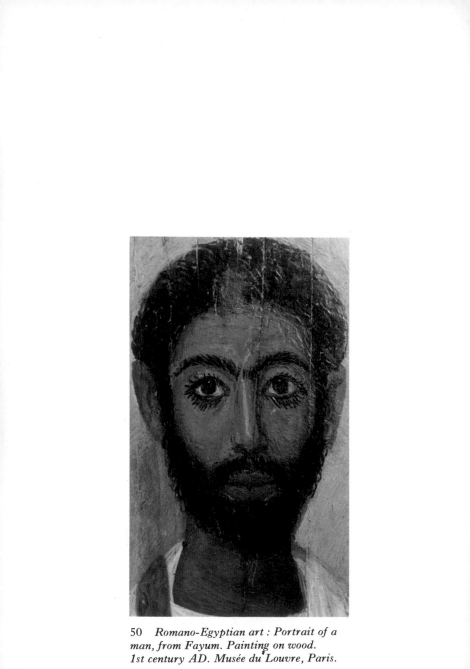

50 *Romano-Egyptian art : Portrait of a
man, from Fayum. Painting on wood.
1st century AD. Musée du Louvre, Paris.*

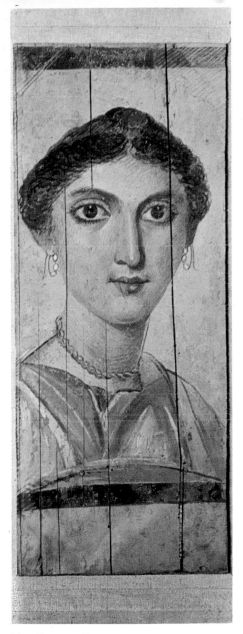

51 *Romano-Egyptian art : Portrait of a
young girl, from Memphis. Painting on
wood. 1st century AD. Musée du Louvre,
Paris.*

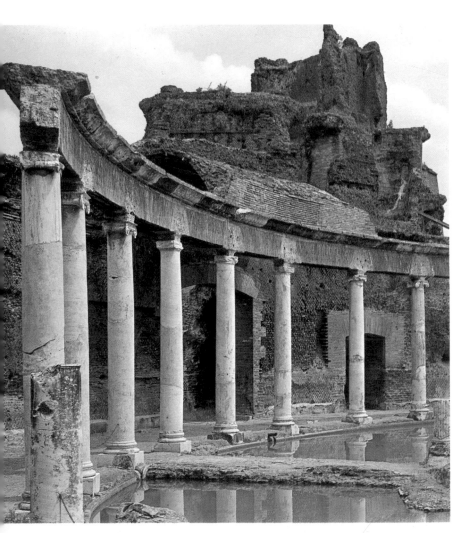

52 *Roman art : Part of the Maritime Theatre in Hadrian's Villa, Tivoli.*
2nd century AD.

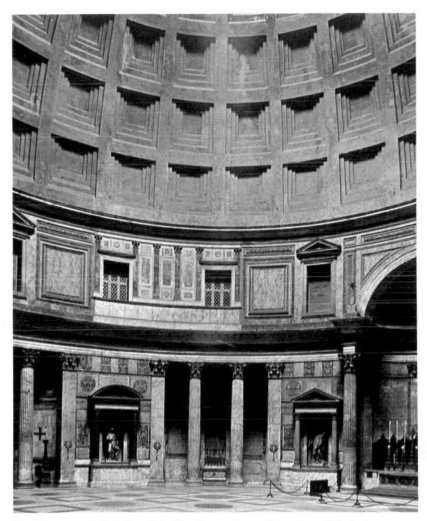

53 *Roman art : Interior of the Pantheon, Rome. 1st century BC–2nd century AD.*

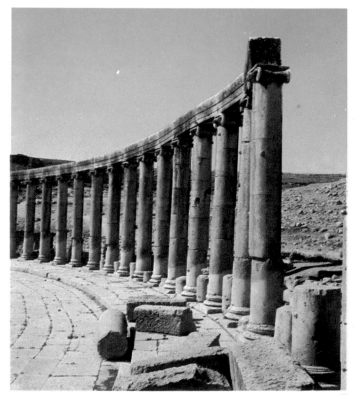

54 *Roman art : Part of the Forum at Jerash. 2nd–3rd century AD.*

which is depicted a battle between the Romans and the Barbarians. The movement is convulsive and frenzied, and the strongly drilled relief figures express the violence of their emotions through their bodies as well as their facial expressions. A remarkably different feeling of balance and serenity emanates from the equestrian statue of Marcus Aurelius (see illustrations 61–2).

The incisive and 'broken' style of the period of Commodus; the exuberant colouring of Severan art; the reappearance of the ancient local substrata during the crisis of the Empire in the third century; the Hellenizing restorations of Gallienus (AD 253–68), and, finally, the spread of Oriental doctrines (the solar and astral cults, among them Mithraism) and the growing taste for abstract and intellectual matters – all these currents contributed to a complex interweaving of motifs up to the time of the Late Empire. They also brought about a crisis in the great Hellenistic background, which until then had remained the dominant factor in Roman art, retaining a particular hold in painting and mosaic work. (To this tradition can be ascribed the mosaics of Piazza Armerina, Sicily, in the fourth century AD, and also those in the Baths of Neptune at Ostia, which date from the third century.) Symbolism and allegory dominated the language of art at the time of the Tetrarchs. The manner of working became simpler but more rigid. In sculpture, the essential features of the figures were executed in relief in hard and precious materials: porphyry was the most commonly used stone at the time. Official statuary underwent considerable changes: emperors became raised in an emphatic manner above all other mortals, and were apparently more attached to an abstract world of their own than to that of their subjects. It was the beginning of those

hierarchical values that were to remain fundamental to Byzantine art and to the figurative expressions of the Eastern Empire. In architecture, the spacious, monumental style of the Late Antique was given life and movement by niches, porticos and ambulatories that created contrasts of light and shade – as may be seen in the Temples of Baalbek, the Baths of Caracalla and Diocletian, in the Theatre of Sabratha and in the Basilica of Maxentius. In Egypt, from the fourth century AD, the impulse derived from the new Christian civilization, and increased contacts with Byzantium, Syria and even with Persia created a gradual but at the same time systematic movement that ultimately overwhelmed the Hellenistic imprint. Works of interest include woven fabrics as well as sculptures, the majority of the latter being in red porphyry; in them the human figure is portrayed in a rigid frontal position, like the busts of the emperors, with their haughty but rather absent-minded look that recalls the portraits of the ancient pharaohs. Finally there are the group compositions from Venice and the Vatican: in one such, the embrace of the Tetrarchs (see illustration 99) the composition was intended to symbolize the new glory of the *Concordia Augustorum*.

The word decline had already been used in reference to Hellenism, and now it was used in respect of the Late Antique. Berenson gave his volume on the Arch of Constantine the subtitle: *On the Decline of Form*. Those parts of the Arch that date from the period of the first Christian Emperor (there are many reliefs from an earlier period) offer in the 'incoherence' of their style, their hard modelling and expressive distortions a new vision, a new way of seeing art. It was no longer Greek and it was to be of the utmost importance in future developments.

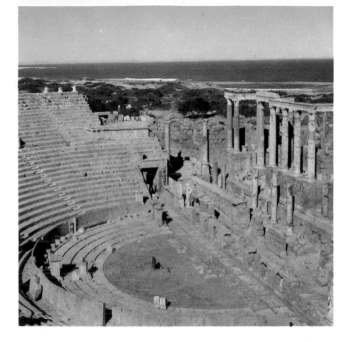

55 Roman art : Theatre at Leptis Magna. 1st century AD
(top). Theatre at Sabratha. 2nd 3rd century AD (bottom).

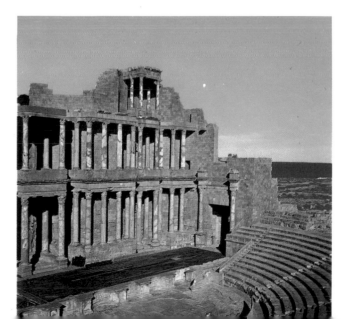

55 Roman art: *Theatre* at Leptis Magna. 1st century AD (top). *Theatre* at Sabratha. 2nd-3rd century AD (bottom).

Among the many theatres built in Africa, these two were exceptional in that they were built entirely of masonry and not on the natural elevations of the terrain that provided the commonest solution. The theatre at Sabratha was the largest in Roman Africa; the *scenae frons*, the wall behind the stage, is notable for its elegant colonnades.

56 Roman art: *Courtyard of the Temple of Jupiter* at Baalbek, 1st-3rd century AD.

An impressive complex of temples arose at Baalbek, begun in the 1st century AD and completed at various periods up to the 3rd century. The complex contained three temples: the so-called Temple of Bacchus, a small round temple often associated with Venus and the Temple of Jupiter.

57 Roman art: *Baths of Caracalla*, 3rd century AD.

These baths represent a milestone in the development of Roman

56

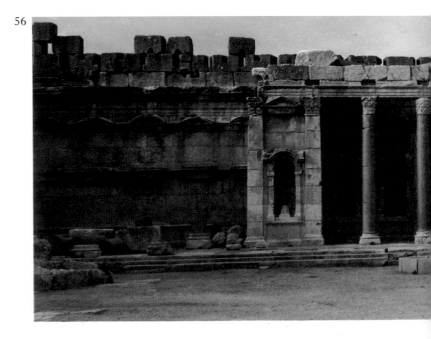

bath architecture, not only through the splendour of their ornamentation but also because of their supremely rational lay-out.

58 Roman art: *Arch of Septimius Severus*, Rome. AD 202–3.
The arch of Septimius Severus was raised in commemoration of the victories gained by the Emperor jointly with his sons Caracalla and Geta over the Parthians. The monument has three arches and is 75½ feet high. The columns stand out sharply on the high base and are detached from the main body. There is a dedicatory inscription on the attic story.

59 Roman art: *Arch of Constantine*, Rome. AD 315.
This is similar to the Arch of Septimius Severus in construction and dimensions (it is slightly under 69 feet high). The treatment of the attic story is different, however, and bears reliefs as well as inscriptions.

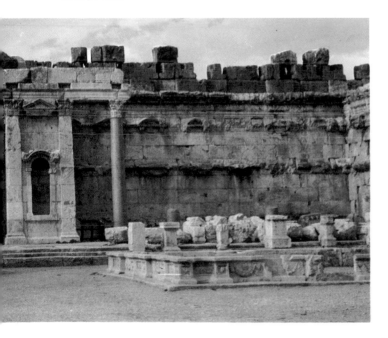

57 *Roman art : Baths of Caracalla, Rome. 3rd century AD.*

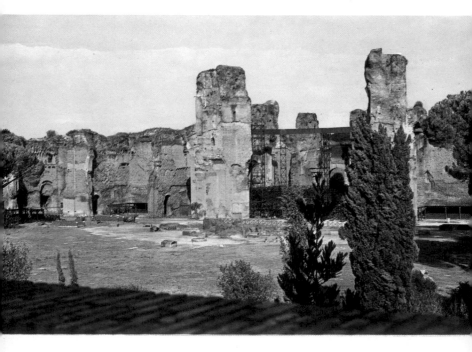

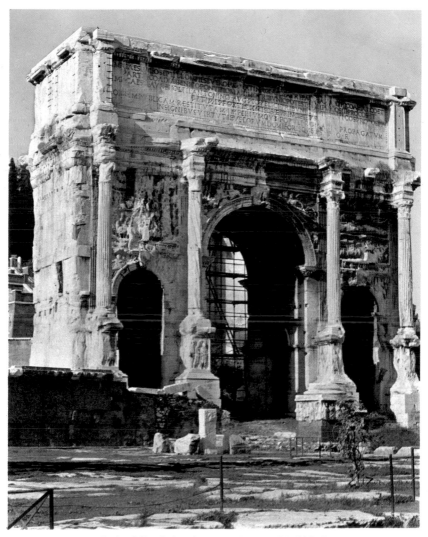

58 *Roman art : Arch of Septimius Severus, Rome. AD 202–3.*

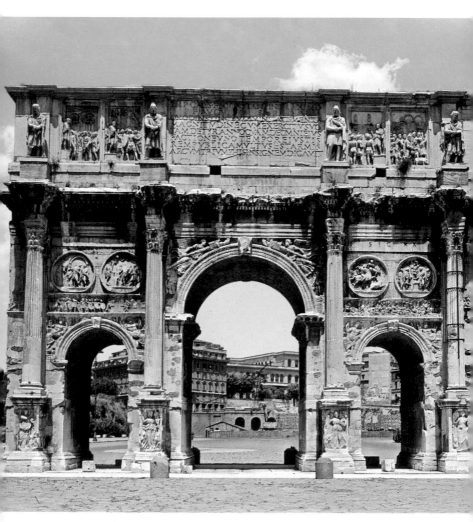

59　*Roman art : Arch of Constantine, Rome. AD 315.*

THE LATE EMPIRE – FROM PROVINCIAL TO CHRISTIAN ART

Christianity was not the principal cause of the artistic changes in Late Antiquity. Christianity was only one among many spiritual movements that started in the East and flooded the Roman environment with rites, cults and sects. Christian art did not make an impression as of something new, rather it was just one of the branches – and not the main one – of the art of the time. Instead of creating a new style or a new iconography, it made the necessary adaptations to Pagan traditions and drew on them. These adaptations arose largely from the new importance of the East and of the provinces in general in the life of the Empire. The axis of Imperial policy gradually shifted to the East, and it was there that the contests for power were often settled. It was there too that political movements pressing for autonomy flourished, while on the eastern frontiers the Empire's most dangerous and warlike enemies were continually threatening. 'The Eastern transformation of life in Late Antiquity is an undeniable fact that cannot escape the scholar's attention' (Schlosser). A renewal of political importance almost always coincides – and not only in the ancient world – with a cultural renaissance. The East was a land of very ancient culture, and it was not surprising that the original substrata of the various Eastern cultures, submerged by Hellenism and Rome, should reappear at the moment when the historical, philosophical and political assumptions on which the dominating culture had been founded, were entering a crisis. Scholars have always underlined the importance of neo-platonism, especially that of Plotinus, in the shaping of a new vision of art, and now, together with this new doctrine that proposed a synthesis of Greek

and Oriental ideas, there was a resurrection of the ancient
'primitive' cults, revived in the new climate of spiritual
curiosity and new forms of art.

It is these elements that confer on Late Antiquity that
'singular aspect of innovation and age' that Schlosser so
clearly saw. The new spiritual demands and the manner
in which they were expressed in art (the schematization
of designs, simplification of forms, the reduction of the
plastic elements – concentrating on those essential features
considered to be the most expressive – as well as all the
distortions that came from this, etc.) did not, of course,
impose themselves all at once on the Roman environ-
ment. They merged with and were bound to the tradi-
tional Hellenistic-Roman elements, and in this way a
fresh tradition began that was to become the dominating

60 *Roman art : Basilica of*
Maxentius, Rome.
AD 308–13.

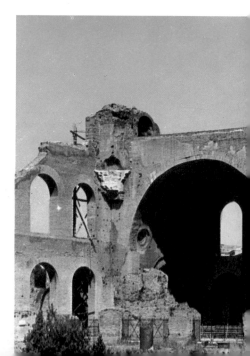

one – especially after Constantine, and especially in the Eastern zone of the Empire. (The word 'dominating' is not in fact intended to mean exclusive, insofar as artistic traditions often take a long time to fade, and a cultural background is never so homogeneous as it may appear in the ordered descriptions of later scholars.)

Thus, in the Eastern countries that had had ancient civilizations, the Hellenistic and, later, Roman cultures were accompanied at certain stages by 'archaic resurrections', some of which were energetically pursued, others less so. They became stronger whenever the recurring crises of the Empire loosened direct contact between the capital and the provinces. And it was for this complex and varied artistic world that such art definitions were coined as: Romano-Mesopotamian, Romano-Syriac, Romano-

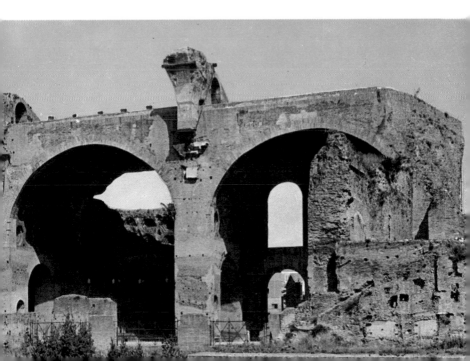

60 Roman art: *Basilica of Maxentius*, Rome. AD 308–13.
Known as the Basilica Nova, this monument is one of the most imposing structures in Late Roman architecture.

61 Roman art: *Column of Marcus Aurelius* (detail), Rome. AD 180–92.
The Aurelian Column differs chiefly from the earlier Trajan Column in its high relief technique and in the greater formalization of the design.

62 Roman art: *Equestrian statue of Marcus Aurelius*, Rome. Second half of 2nd century AD.
The equestrian statue of Marcus Aurelius on the Capitol was widely taken up as a model during the Renaissance.

63 Roman art: *Detail of the Arch of Constantine*, Rome. AD 312–5.
Many earlier sculptures were included among the decorative reliefs of this arch, which is in many ways representative of the composite state of Late Roman art.

64 Roman art: *Detail of the Ludovisi Sarcophagus*. 3rd century AD. Museo Nazionale Romano, Rome.
Crowded battle scenes were especially popular forms of sarcophagus decoration in this period.

65 Roman art: *Psyche*, from Capua. 2nd century AD. Museo Archeologico Nazionale, Naples.
In this fine carving emphasis is aptly given to the face, reminding the observer of Psyche's concern with the soul.

66 Roman art: *Portraits from the Imperial age*. (Top, from left) *Caracalla*. Kestner-Museum, Hanover. *Diocletian*. Ny Carlsberg Glyptotek, Copenhagen. (Bottom, from left) *Hadrian*. British Museum, London. *Antinous*. Museo Archeologico, Florence.
Throughout the various epochs and the various stylistic tendencies, Roman portraiture kept a remarkable and singular vitality.

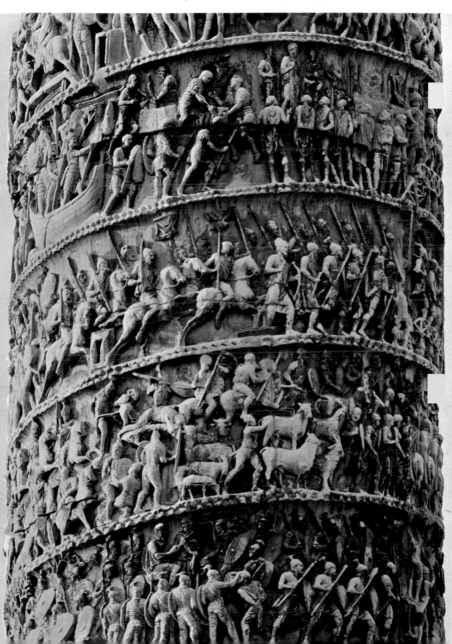

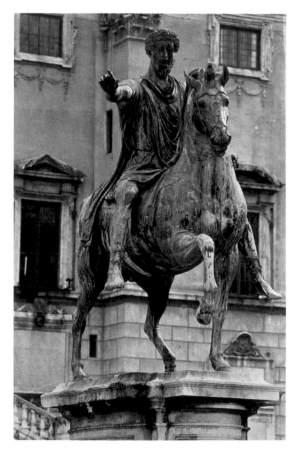

62 *Roman art : Equestrian statue of Marcus
Aurelius, Rome. Second half of 2nd century AD.*

63 *Roman art : Detail of the Arch of Constantine, Rome. AD 312–5.*

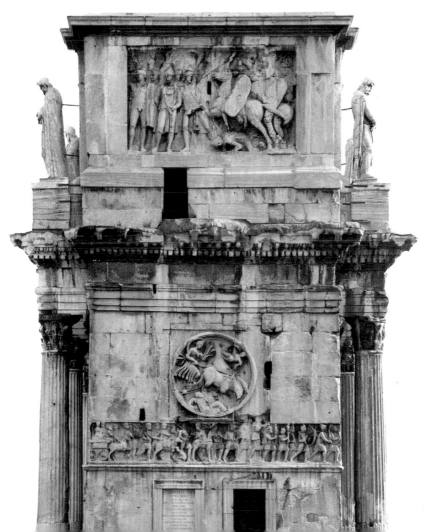

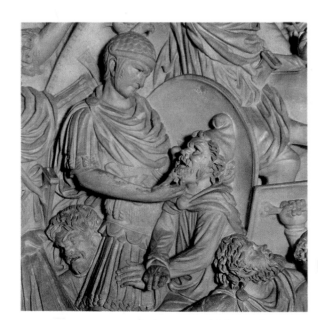

64 *Roman art : Detail of the Ludovisi Sarcophagus.*
3rd century AD. Museo Nazionale Romano, Rome.

65　*Roman art : Psyche, from Capua. 2nd century AD. Museo Archeologico Nazionale, Naples.*

101

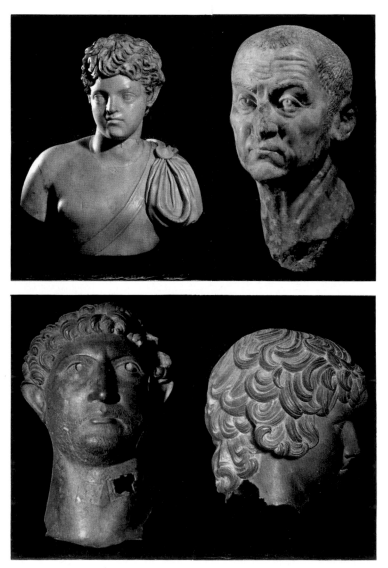

66　　*Roman art : Portraits from the Imperial age. (Top, from left)*
Caracalla. Kestner-Museum, Hanover. Diocletian. Ny Carlsberg

Egyptian, and so forth. It was a world of rich and multiple aspects, and fascinating like all composite cultures. At times, a strange kind of mysticism, developing in Asia Minor, united with an exuberant decorative richness that was clearly Oriental in origin. It was just this complex and esoteric splendour that created the subtle fascination of the Artemis statue at Ephesus, a work that would have been outstanding in any age (see illustration 75).

Certain busts of ladies, emperors or other illustrious persons revealed an acquaintance with Roman models, but they have been freely interpreted by original artists open to many different influences. The funerary stelae found at Palmyra are particularly remarkable. The image of the dead person was depicted on the stelae which were used to cover the graves. They represent one of the highest forms of the new Eastern art, with its frontal representation and splendid sumptuousness. It is not surprising to find such original and vibrant works of art at Palmyra, if we remember the extent of the prosperity and power that this ancient caravan city had attained by the third century AD, and the way in which it had succeeded in making itself completely independent from Rome. In the same way as Eastern art was to have a decisive importance in the development of Byzantine figurative art, so the art of the Western provinces of the Empire (where, similarly, the ancient local substratum flowered alongside the Roman culture) asserted its own importance. A parallel phenomenon, analogous to events in the Middle East, occurred in the regions of Europe that had been reached by Roman expansion. There the art of the conquerors was grafted on to that of the local inhabitants; this process brought forth original results and contributed to the formation of the medieval style in the West.

The peoples who inhabited Germany, Gaul, Spain and Scandinavia did not possess traditions of culture and civilization of a Western Mediterranean type before the Roman occupation. Contacts, however, were not lacking either with Italy or the Middle East regions. They experienced the art of Greece and then later that of the Etruscans. During the Iron Age, the principal civilization of Western Central Europe is known as the Hallstatt, from an Austrian centre in which a necropolis, rich in objects dating from that epoch, has been discovered. The civilization of Hallstatt lasted between about the ninth and fifth centuries BC, and left primitive objects containing motifs of the ancient Danubian tradition mixed with Mediterranean and Etruscan influences. In the region of modern Switzerland a more evolved culture developed between the fifth and first century BC: this is called La Tène, after a site on the Lake of Neuchâtel where many important finds have been made. The civilization of La Tène was born from a fusion between the Hellenic-Etruscan influence and works coming from the Danube zone and others of a more Eastern origin, derived from the Scythians. The Scythians lived in the Middle-Eastern steppes of Southern Russia, in Kuban and in the Crimea. They developed their own civilization about the seventh century BC and produced objects and ornaments of considerable artistic interest: gold and bronze worked in relief, figures of animals interpreted with lively imagination, clasps and breastplates decorated with complicated ornamental motifs – all their work demonstrated a feeling for an elegant and stylized line. The most typical productions of the Scythian people came from the sumptuous tombs of Kuban, where the bodies of the princes were luxuriously surrounded with pieces of golden furniture

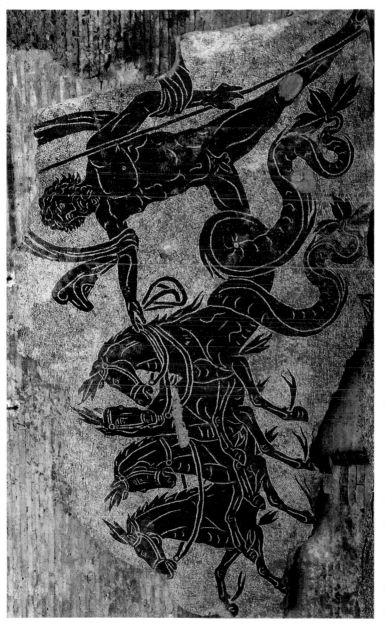

67 *Roman art: Mosaic from the Baths of Neptune, Ostia. Second half of 3rd century AD.*

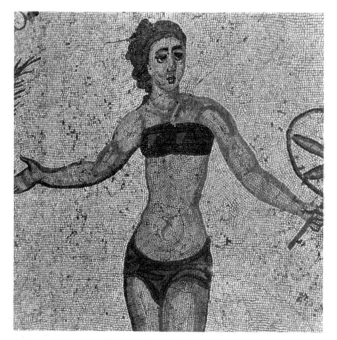

68 *Roman art : Girl at the bath. Detail of a mosaic in the*
Imperial Villa near Piazza Armerina, Sicily. 3rd–4th
century AD.

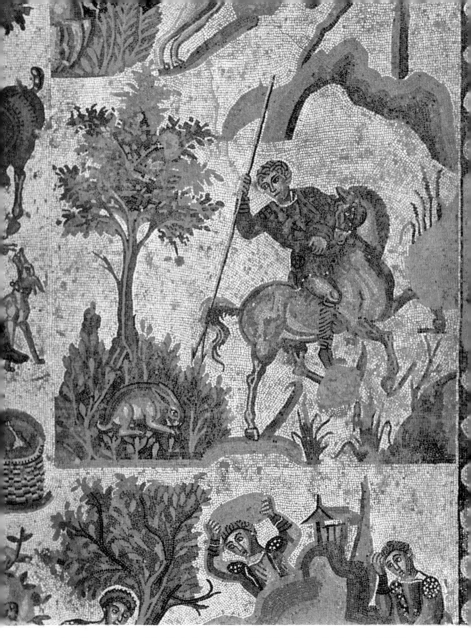

69 *Roman art : The little hunt (detail). Mosaic in the Imperial Villa near Piazza Armerina, Sicily. 3rd–4th century AD.*

67 Roman art: *Mosaic from the Baths of Neptune*, Ostia. Second half of 3rd century AD.
Mosaic decoration, originally limited to floors, was soon applied to walls, depicting large-scale mythical episodes and scenes of hunting and games. In the floor mosaic reproduced here the triumph of the god Neptune is rendered with superb vigour.

68 Roman art: *Girl at the bath*. Detail from a mosaic in the Imperial Villa near Piazza Armerina, Sicily. 3rd–4th century AD. The mosaic illustrated here is from the 'Room of the Ten Girls': the entire work features ten girls in brief bathing slips who wait on the edge of the bath; some are shown carrying out gymnastic exercises.

69 Roman art: *The little hunt* (detail). Mosaic in the Imperial Villa near Piazza Armerina, Sicily. 3rd–4th century AD.
There are more than forty floor decorations of exceptional beauty and variety at Piazza Armerina. The hunting scenes are particularly rich and are described with a vivacious sense of colour and a mastery of composition.

70 Roman art: *Floor mosaic*. Corinth Museum.
In this sophisticated mosaic the geometrical motif is rendered with great refinement in subtle colours.

71 Roman art: *Gold brooch with pendants*. British Museum, London.
The splendour of much Roman jewellery is founded not only on the undoubted technical skill of the craftsmen but also on the richness of the materials used.

72 Provincial art: *Helmet with mask*, from Homs, Syria. 1st century AD. National Museum, Damascus.
A round helmet is set over a mask whose interior is entirely covered in silver. A sure and incisive hand has traced the lines of the nose and the half-opened mouth; this work, perhaps by a Syrian artist, reveals oriental influences.

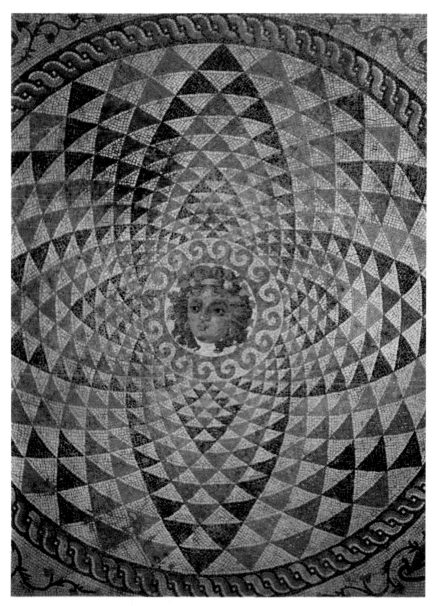

70 *Roman art : Floor mosaic. Corinth Museum.*

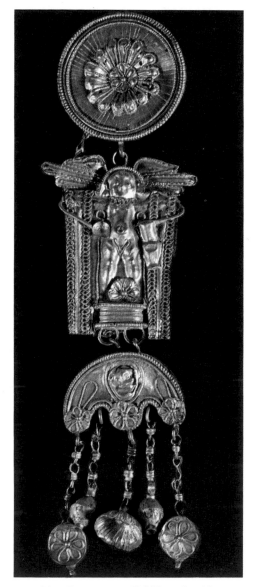

71 *Roman art : Gold brooch with
pendants. British Museum, London.*

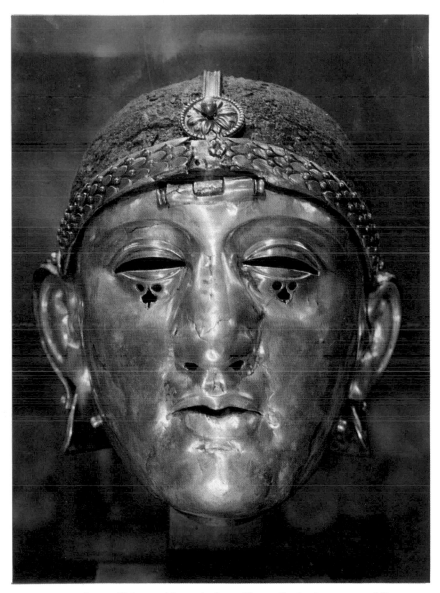

72 *Provincial art : Helmet with mask, from Homs, Syria. 1st century AD.*
National Museum, Damascus.

111

and golden ornaments. Also from the epoch of La Tène were buckles, bracelets and bronzes of a fairly evolved workmanship. The acquaintance with Greek and Italic production is evident in pottery as well as in sculpture. It is almost certain that the peoples who produced the civilizations of Hallstatt and La Tène were Celts, belonging to that group of barbarian peoples originating in the Upper Danube and widely distributed in Europe, who had settled in many parts of Italy and in Spain and the Balkans. Their taste for geometrical decoration was accompanied by a tendency, in portraiture, towards an expressive and realistic style – although this contained certain fanciful characteristics and sometimes verged on caricature. Typical products of the Celts consisted of objects in metal, jewels, coins, buckles with animal motifs, and enamels. The Mediterranean zones of the Celtic occupation, particularly France and Italy, reveal a greater maturity and nobility of expression than the areas of the hinterland; this was because of their numerous contacts with the Graeco-Etruscan world. In architecture the Celts absorbed the Greek models, especially in the temples they raised to the various deities. But, like most peoples subject to frequent migrations, the Celts have left far too little trace to make a thoroughly documented appraisal possible. The Celts reached Britain and Ireland in the third century BC as part of their expansion to the north – although they never reached Denmark, which was occupied by a people of Teutonic stock. Celtic art, however, managed to penetrate even this region either through imports, war booty or, more rarely, by the work of isolated artists who had emigrated to the north. One of the most beautiful works of Celtic craftsmanship has in fact come from Denmark: the great silver

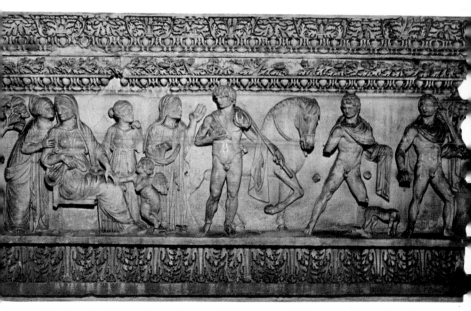

73 *Provincial art : Sarcophagus of Phaedra and Hippolytus, from Tripoli,
Syria. 2nd century AD. Archeological Museum, Istanbul.*

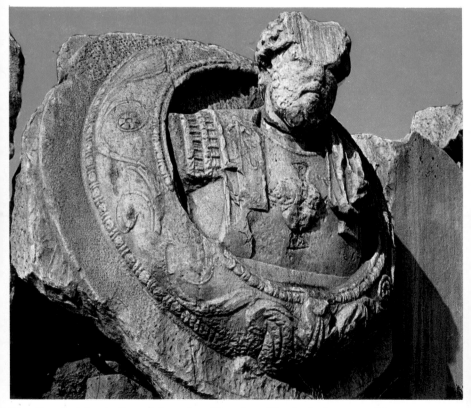

74 *Provincial art : Bust of Antoninus Pius, from Eleusis. 2nd century AD.*

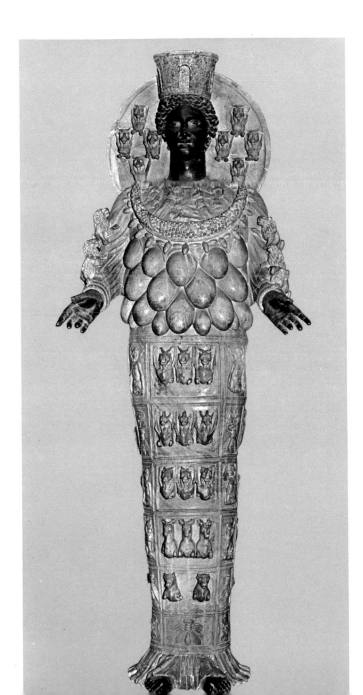

115

73 Provincial art: *Sarcophagus of Phaedra and Hippolytus*, from Tripoli, Syria. 2nd century AD. Archeological Museum, Istanbul. This sarcophagus, richly decorated with leaf motifs depicts in the central fascia the famous myth of Phaedra and Hippolytus. The classical tradition is clearly evident in the treatment of the figures.

74 Provincial art: *Bust of Antoninus Pius,* from Eleusis. 2nd century AD.
The medallion busts of Antoninus Pius are among the most interesting pieces of provincial Roman sculpture to survive. They were inserted into the building that the Emperor added to the propylaea at Eleusis.

75 Provincial art: *Artemis of Ephesus.* 2nd century AD. Museo Archeologico Nazionale, Naples.
In this very ornate image of Artemis, goddess of nature and a symbol of fertility (clearly indicated by the swollen breasts) there is a marked chromatic contrast between the bronze of the face, hands and feet and other parts of the body. The work dates from the reign of Hadrian (AD 117–38).

76 Provincial art: *Statue of Jupiter Heliopolis*, from Baalbek. 2nd–3rd century AD. Musée du Louvre, Paris.
Greek naturalism is here heavily overlaid with decorative elements belonging to the traditional styles of the eastern Mediterranean.

77–8 Provincial art: *Reliefs from Palmyra.* 2nd–3rd century AD. Ny Carlsberg Glyptotek, Copenhagen.
The reliefs are funerary stelae bearing likenesses of the dead person. The spirit of these works is neither exclusively Roman nor Western, and they clearly reveal their Eastern influence: the figures are rigidly frontal and massively portrayed; the treatment of the eyes, which are large and elongated, is another pointer to Eastern inspiration.

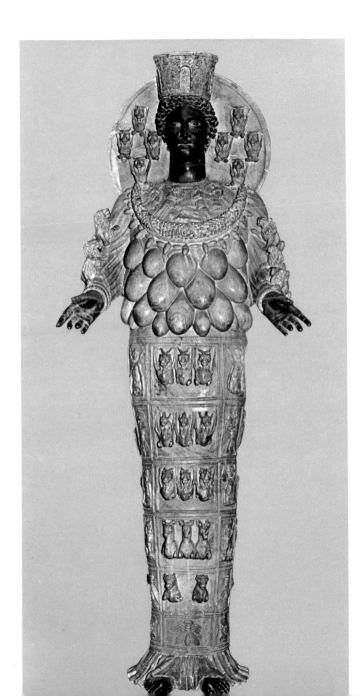

73 Provincial art: *Sarcophagus of Phaedra and Hippolytus*, from Tripoli, Syria. 2nd century AD. Archeological Museum, Istanbul. This sarcophagus, richly decorated with leaf motifs depicts in the central fascia the famous myth of Phaedra and Hippolytus. The classical tradition is clearly evident in the treatment of the figures.

74 Provincial art: *Bust of Antoninus Pius,* from Eleusis. 2nd century AD.
The medallion busts of Antoninus Pius are among the most interesting pieces of provincial Roman sculpture to survive. They were inserted into the building that the Emperor added to the propylaea at Eleusis.

75 Provincial art: *Artemis of Ephesus*. 2nd century AD. Museo Archeologico Nazionale, Naples.
In this very ornate image of Artemis, goddess of nature and a symbol of fertility (clearly indicated by the swollen breasts) there is a marked chromatic contrast between the bronze of the face, hands and feet and other parts of the body. The work dates from the reign of Hadrian (AD 117–38).

76 Provincial art: *Statue of Jupiter Heliopolis*, from Baalbek. 2nd–3rd century AD. Musée du Louvre, Paris.
Greek naturalism is here heavily overlaid with decorative elements belonging to the traditional styles of the eastern Mediterranean.

77–8 Provincial art: *Reliefs from Palmyra*. 2nd–3rd century AD. Ny Carlsberg Glyptotek, Copenhagen.
The reliefs are funerary stelae bearing likenesses of the dead person. The spirit of these works is neither exclusively Roman nor Western, and they clearly reveal their Eastern influence: the figures are rigidly frontal and massively portrayed; the treatment of the eyes, which are large and elongated, is another pointer to Eastern inspiration.

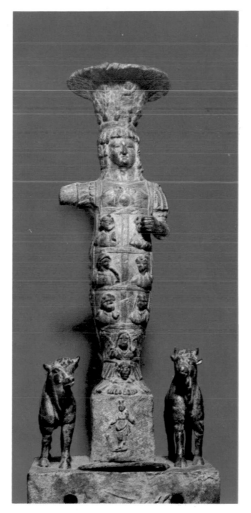

76 *Provincial art : Statue of Jupiter*
Heliopolis, from Baalbek. 2nd–3rd century
AD. Musée du Louvre, Paris.

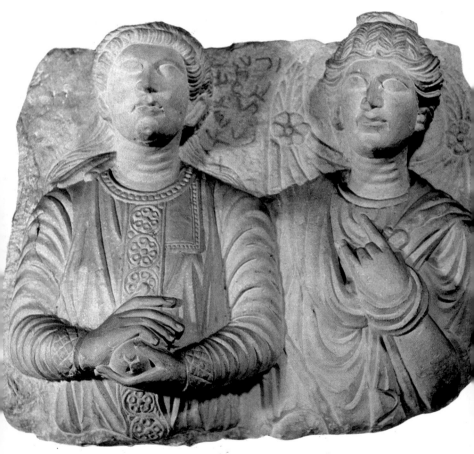

77 *Provincial art : Relief, from Palmyra. 2nd–3rd century AD. Ny Carlsberg Glyptotek, Copenhagen.*

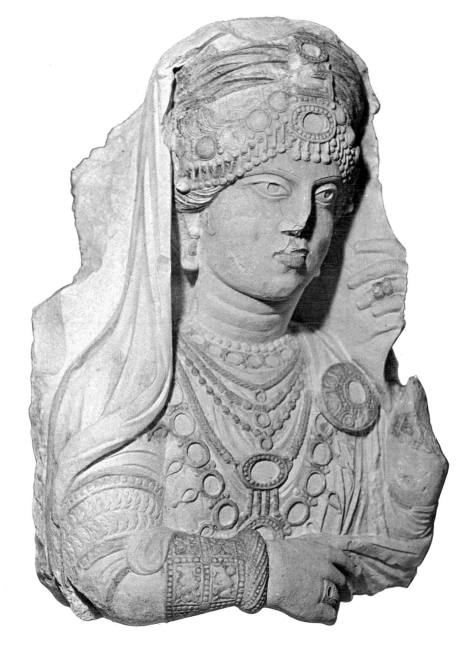

cauldron found in a bog at Gundestrup in Himmerland (see illustration 88). The sides and the base of the cauldron are decorated in relief with mythological and ritual scenes and with figures of real and imaginary animals. The variety and richness of the decoration makes the object a truly exceptional piece. The highly developed quality of the execution and the stylistic details raise the question whether the receptacle may not originally have come from the Middle Danube, where several tribes of Celtic stock lived who were particularly skilled in the working of silver.

The Celtic migrations reached Spain in two waves (the first about 1000 BC, the other about 600 BC) and brought many Hallstatt elements into the existing Iberian cultures, as can be seen in certain types of weapons. The Hallstatt elements were merged with others of local origin, and to them, at a later date, were added yet others from Phoenicia and Greece. This complex blending of different cultures did not in fact produce many works of outstanding interest. Among the better known and more unusual objects is the Chariot of Merida, made of bronze and dating from the first century BC. It takes up the familiar motif of the chariot that, in its various interpretations and different ritual functions, has always been popular with the ancient civilizations, from Crete to Scandinavia. The Roman conquest of Spain tended to obliterate the more original Iberian traditions and founded in their place an art that was by and large similar to that produced on Italic soil.

The Gallic civilization developed as part of the Celtic world and shared characteristics of the Hallstatt and La Tène cultures. The Gauls were themselves groups of Celts who had occupied Gaul about the 7th century BC. (It was the Romans who called them Gauls, whereas the

Greeks called them Galatians.) In the Hallstatt period, a dominant feature of their civilization was their weapons – especially swords with long blades – and pottery with geometrical decorations. In the fourth century, corresponding to the La Tène period, their works still include many different types of bronze and iron weapons, pottery turned on the wheel, enamels, and bronze plate.

When the Roman occupation had extended over the whole of Gaul, local styles were changed profoundly and artists applied themselves to following Roman models. Many forms of art in the Gallic region between the first century BC and the Christian era, have since been termed Gallo-Roman, because they contained elements that the local inhabitants had learnt from their conquerors. However, even in those objects that most clearly reveal Roman influence, there remains sufficient rugged expressiveness and lack of restraint for such works to be properly classified as original examples of provincial art.

The Iron Age developed in Northern Europe through its contact with Celtic civilization much later than in the Central Southern regions. Echoes of the Mediterranean cultures had already arrived in the Scandinavian peninsula during the Bronze Age from the Eastern routes of Persia, the Caucasus and from Siberia. This explains the many Eastern-looking ornamental motifs that have been found in gold, silver and bronze plate, also in shields and weapons.

Although the Celts never occupied Scandinavia or Denmark, they sent their products there and spread the taste for weapons and buckles decorated with fantastic and geometrical designs, and for heavy gold jewellery, and representations of animals, which, although stylized, were vivacious and expressive. In the first centuries of the

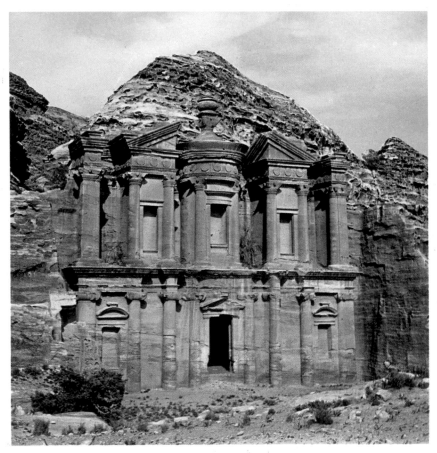

79 *Provincial art : Façade of Ed-Deir, Petra.*

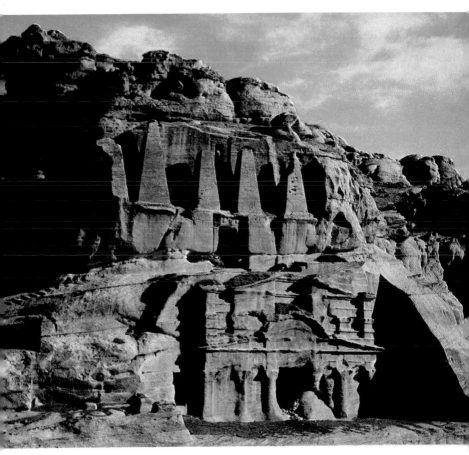

80 *Provincial art : Rock tombs over the entrance to the Sikh, Petra.*

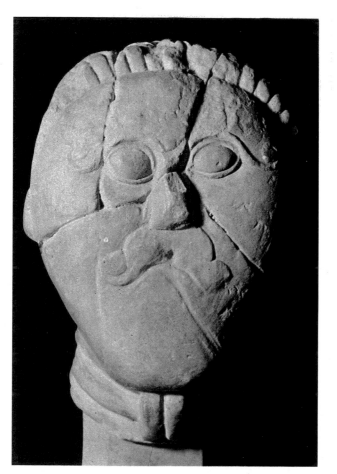

81 *Celtic art: Head of a man. 1st century BC–1st century*
AD. Musée des Antiquités Nationales, Saint-Germain-
en-Laye.

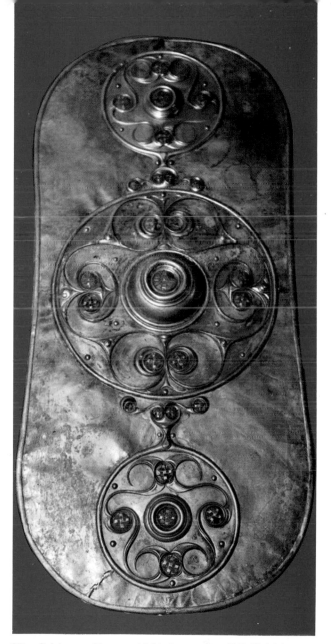

82 *Celtic art : Bronze shield. 1st century BC. British
Museum, London.*

79 Provincial art: *Façade of Ed-Deir,* Petra.
This rock-cut façade of Late Hellenistic inspiration is constructed on two floors with colonnades of different orders and architraved doorways.

80 Provincial art: *Rock tombs over the entrance to the Sikh*, Petra.
These obelisk tombs stand over the narrow entrance to the extraordinary rock city of Petra, the former capital of the Nabateans annexed to the Roman Empire in AD 106.

81 Celtic art: *Head of a man.* 1st century BC–1st century AD.
Musée des Antiquités Nationales, Saint-Germain-en-Laye.
Celtic artists worked mainly in abstract patterns, and when they did tackle the human figure the results were likely to be formalized.

82 Celtic art: *Bronze shield*, from the Thames at Battersea, London. 1st century BC. British Museum, London.
This oval shield is one of the most beautiful of the Celtic objects. It is ornamented with a series of curvilinear motifs.

83 Gallic art: *Dancing girl.* Small bronze. Musée Historique de l'Orléanais, Orléans.
This small figure is boldly executed in a style characteristic of true provincial art as distinct from Roman-influenced work.

84 Gallo-Roman art: *Bronze figure.* 3rd–1st century BC. Musée des Antiquités Nationales, Saint-Germain-en-Laye.
The shaping of the bust is Celtic, but the influence of Roman portraiture is clearly revealed in the head.

85 Gallic art: *Wooden figure.* Musée Historique de l'Orléanais, Orléans.
This Gallic figure is a crude, minimally worked example of the numerous wooden votive figures that have survived from early Celtic cultures.

86 Gallic art: *Statue of a god.* 3rd century BC. Musée des Antiquités Nationales, Saint-Germain-en-Laye.
The statue depicts a Celtic divinity identified with the boar, symbol of fertility throughout Gaul.

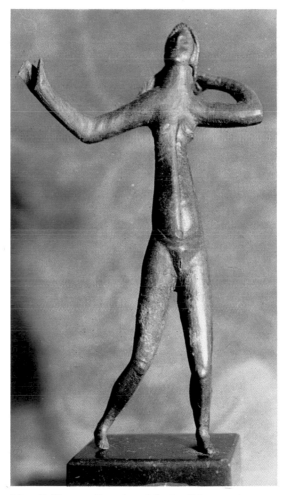

83 *Gallic art : Dancing girl. Small bronze. Musée
Historique de l'Orléanais, Orléans.*

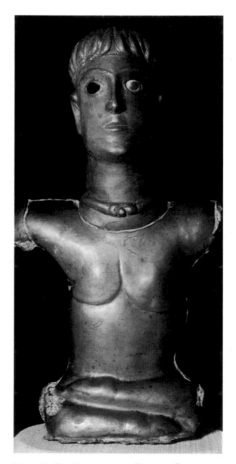

84 *Gallo-Roman art : Bronze figure.*
3rd–1st century BC. Musée des
Antiquités Nationales, Saint Germain-
en-Laye.

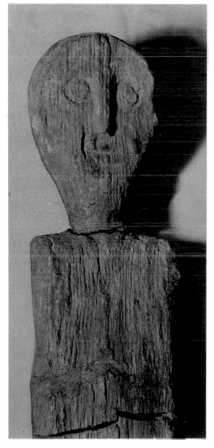

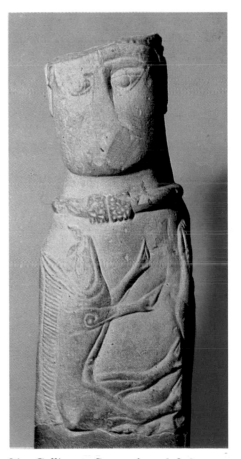

85 *Gallic art : Wooden votive figure.*
Musée Historique de Orléanais,
Orléans.

86 *Gallic art : Statue of a god. 3rd century*
BC. Musée des Antiquités Nationales,
Saint-Germain-en-Laye.

129

Christian era, aspects of Roman civilization reached the North indirectly through the peoples of Central Europe, and also by means of certain contacts that appear to have been made between the Roman emperors and the chiefs in those regions. This is revealed in some precious objects of Roman craftsmanship discovered in Danish tombs. However, these contacts did not make any noticeable mark on local production.

The first expressions of an art that can properly be called Christian are usually not to be found earlier than the fourth century AD. Before that time the diffusion of the new religion in the Roman world took place gradually. In essence works of Christian origin differ greatly from those of the contemporary Pagan culture. We can only speak of Early Christian art after the advent of Constantine and the Edict of Milan (AD 313), which marked a decisive turning point in the course of Christian art.

Before Constantine there was hardly any Christian architecture. In the Christian house at Dura-Europos (Syrian city of the Euphrates), the rooms were arranged in the interior of an ordinary private house without any specifically 'Christian' elements being discernible. This same 'architectonic neutrality' (as Graber has called this lack of specific elements) applied also to sacred buildings : unlike Roman temples or Jewish synagogues, the oldest churches of Rome (called *tituli*) appear to have been nothing more than rooms inserted into private houses. This spirit of extreme simplicity appears also in the ancient Cathedral of Bishop Theodorus at Aquileia, which, although founded after the Edict of Milan, had not assumed any of the characteristics of the Constantine basilica.

87 *Celtic art : Bronze chariot, from Merida. 1st century BC. Musée des Antiquités Nationales, Saint-Germain-en-Laye.*

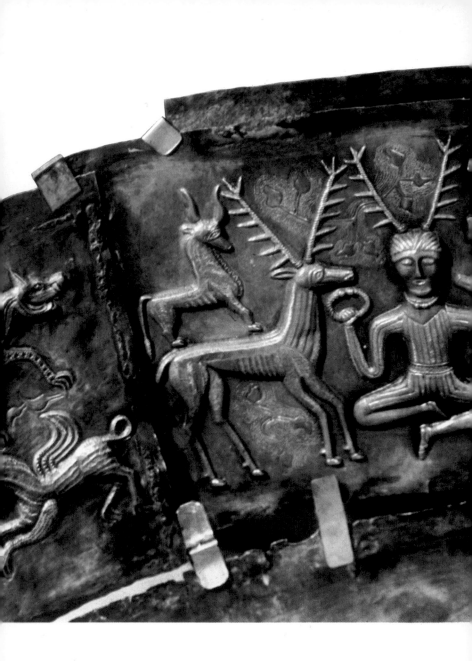

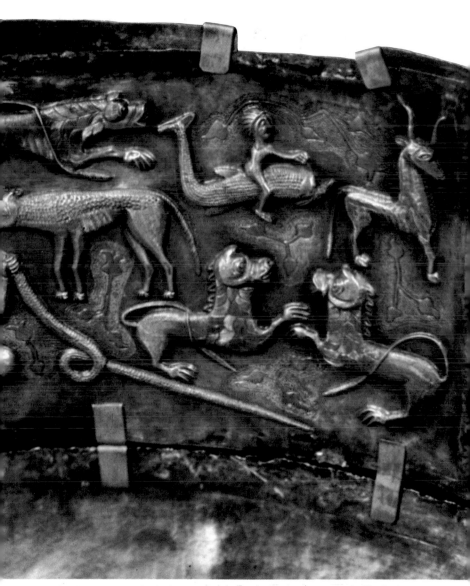

88 *Celtic art : Detail of silver cauldron, from Gundestrup. Probably 2nd–3rd century AD. National Museum of Denmark, Copenhagen.*

87 Celtic art: *Bronze chariot*, from Merida. 1st century BC.
Musée des Antiquités Nationales, Saint-Germain-en-Laye.
The Celtic peoples, although accepting the Greek inheritance,
preferred to work in more simplified decorative styles, as can be
seen in this chariot composition of horse and rider, dog and boar.

88 Celtic art: *Detail of silver cauldron*, from Gundestrup.
Probably 2nd–3rd century AD. National Museum of Denmark,
Copenhagen.
This cauldron is one of the finest pieces of Celtic craftsmanship;
the sides and base are decorated in relief with mythological and
ritual scenes, and with figures of real or imaginary animals. Its
inventiveness and the lively disposition of the figures make this a
work of exceptional importance.

89 Gallo-Roman art: *Bronze Bacchus*. Musée Historique de
l'Orléanais, Orléans.
This figure shows plainly the influence of the Hellenistic style;
this, added to Roman ideas, played a great part in the shaping of
Gallic civilization.

90 Scythian art: *Vase in yellow amber*. From Kul Oba in the
Crimea. 4th century BC. Victoria and Albert Museum, London.
Many beautiful works of art have come from the graves of Kuban,
where the funerary furnishings of the princes were especially rich.
Figures on the vase remind us of Greek influence in the region.

91 Late Roman art: *Vase in painted glass*, from Himmlingøje.
National Museum of Denmark, Copenhagen.
The influences of classical art penetrated Northern Europe
through the importation of various objects such as this vase with
figures of animals portrayed against a neutral background.

92 Gallo-Roman art: *Stele with the goddess Epona*. Musée
Denon, Chalon-sur-Saône.
The goddess Epona, protectress of animals, was at one time
believed to have been originally a Roman deity, but she is more
typical of the Celtic world and was in fact introduced only at a
later date into the cults of Rome.

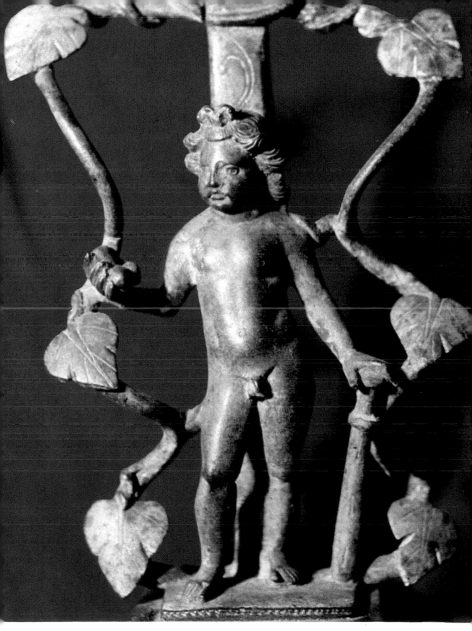

89 *Gallo-Roman art : Bronze Bacchus. Musée Historique de l'Orléanais, Orléans.*

90 *Scythian art : Yellow amber vase, from Kul Oba, Crimea.
4th century BC. Victoria and Albert Museum, London.*

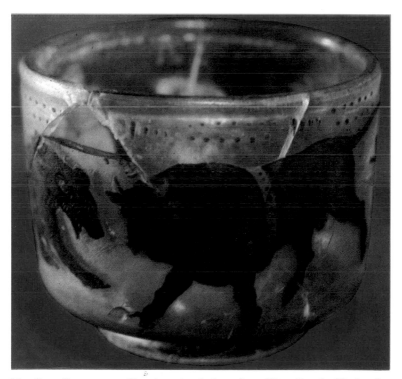

91 *Late Roman art : Vase in painted glass, from Himmlingøje. National Museum of Denmark, Copenhagen.*

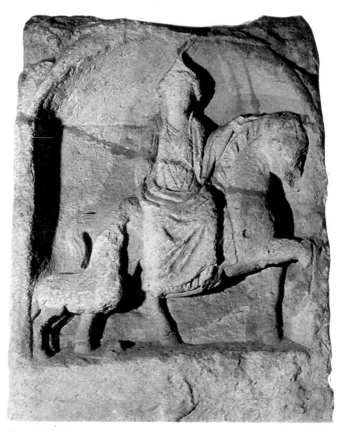

92 *Gallo-Roman art : Stele with the goddess Epona. Musée
Denon, Chalon-sur-Saône.*

The paintings of the catacombs and the sculptured sarcophagi give us an impression of what Christian art was like at its dawn. The style of representation was entirely drawn from that favoured by well-to-do Pagans (and the Christians, who adopted them, must have certainly belonged to the wealthier classes). It is now well known that the catacombs were not meeting places, nor refuges to escape from persecution, but simple subterranean cemeteries similar to those used by the Pagans and by the Jews. These cemeteries were often made up of several floors one above the other and they had numerous corridors and ambulatories set in the walls, from which graves or rectangular cavities were hewn out to receive the bodies of the deceased. The graves that contained people of importance were sometimes ornamented with an arch (*arcolosium*), or with stuccos or paintings. The body of a martyr was generally put in a small room called a crypt or *cubiculum*, and the catacomb often took its name from the martyr. The term catacomb is derived from the cemetery of San Sebastian on the Appian Way, which was called *catacumbas*. The word is of doubtful etymology: it possibly meant that the cemetery had been placed in a depression in the ground, which was in fact the only kind of cemetery known and used throughout the Middle Ages. Later the meaning of the word was extended to include other forms.

Both in the decoration of sarcophagi and in the cemetery paintings, a new Christian iconography slowly formed: it drew widely on Pagan motifs and myths (Orpheus, Amor and Psyche) which were then adapted to the new Christian symbolism. However, the style always remained similar to that of the contemporary Pagan works, so much so that in those representations where the

93 *Early Christian art : The grapes and the peacock (top).*
Head of a boy (bottom). Wall paintings from the
Catacombs of San Sebastian, Rome.

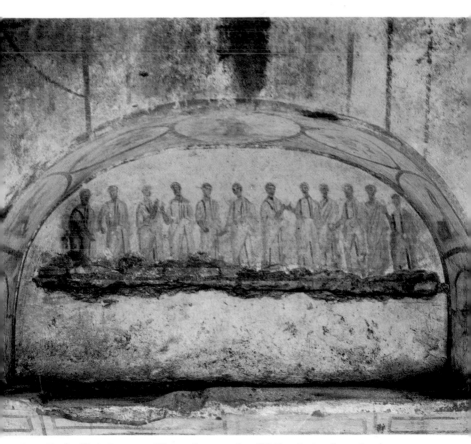

94 *Early Christian art : The twelve apostles. Wall painting from the*
Aurelian Hypogeum, Rome. c AD 220–40.

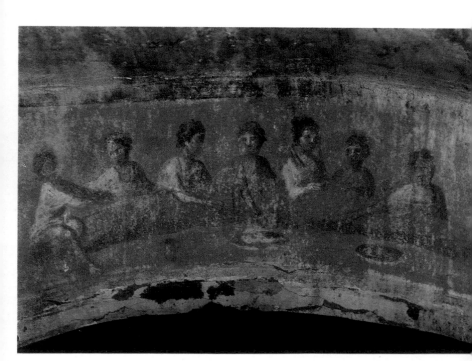

95 *Early Christian art : The banquet. Wall painting from the Catacombs of Priscilla, Rome. 2nd–3rd century AD.*

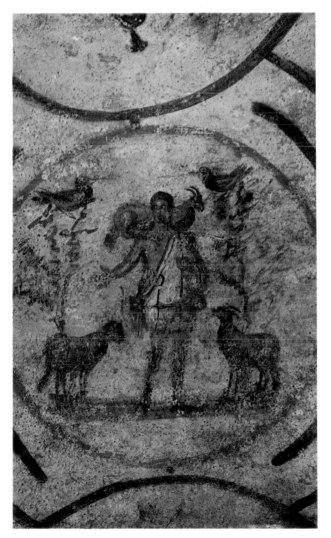

96 *Early Christian art : The good shepherd. Wall
painting from the Catacombs of Priscilla, Rome. 2nd–3rd
century AD.*

93 Early Christian art: *The grapes and the peacock* (top). *Head of a boy* (bottom). Wall paintings from the Catacombs of San Sebastian, Rome.
The paintings of San Sebastian are as well executed as the most refined Pompeian wall painting. This cemetery is believed to have sheltered the bodies of Peter and Paul.

94 Early Christian art: *The twelve apostles.* Wall painting from the Aurelian Hypogeum, Rome. *c* AD 220–40.
The technique and style of the first Christian pictures have much in common with the Pagan frescoes of the time, although some of them look more sketchy as though they had been hurried.

95 Early Christian art: *The banquet.* Wall painting from the Catacombs of Priscilla, Rome. 2nd–3rd century AD.
The art of the first Christians took the form of wall paintings, and the banquet scene – with its mystical overtones – was a theme that recurred many times.

96 Early Christian art: *The good shepherd.* Wall painting from the Catacombs of Priscilla, Rome. 2nd–3rd century AD.
The figure of the good shepherd was another theme prominent in the repertoire of the early Christian artists.

97 Early Christian art: *Madonna and Child.* Wall painting from the Cimitero Maggiore, Rome. Beginning of 4th century AD.
The *Madonna and Child* is one of the most vivid works of Early Christian art. The Virgin, seen from the front, raises her hands in an attitude of prayer. On either side of the figure has been traced the monogram XP (formed from the Greek word for Christ).

98 Early Christian art: *Apse of the Basilica of San Salvatore,* Spoleto. End of 4th century AD.
The Christians of the 4th century borrowed from the basilicas of classical architecture. A common type had one or more apses, and was divided into three or five sections by colonnades.

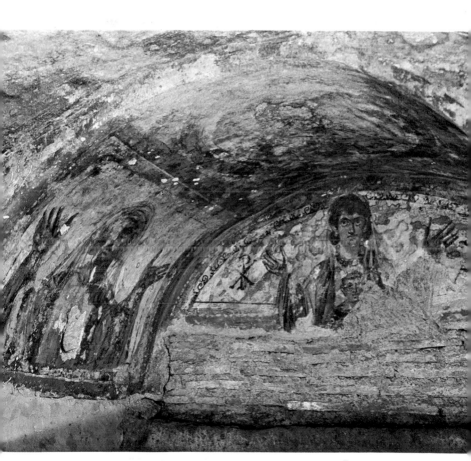

97 *Early Christian art : Madonna and Child. Wall painting from the*
Cimitero Maggiore, Rome. Beginning of 4th century AD.

98 *Early Christian art : Apse of the Basilica of San Salvatore, Spoleto. End of 4th century AD.*

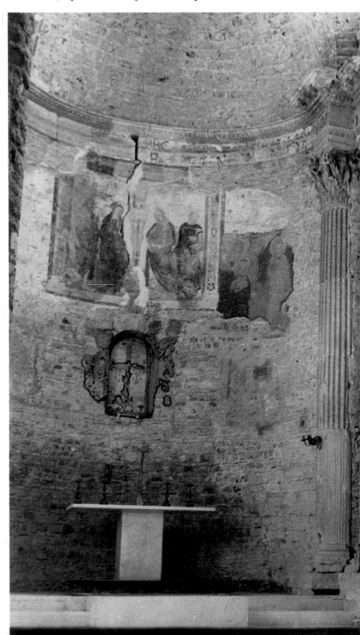

Christian subject was not visible, they could have been used just as easily to decorate any Pagan villa or cemetery. The specifically Christian repertoire was quite limited, and was used again and again, for example, in the paintings on sarcophagi. The subject matter turned almost continually around the concept of salvation; many themes alluded to this concept symbolically, for example the baptism of Christ, the story of Jonah and the whale (one of the most popular subjects), Daniel among the lions, the raising of Lazarus, and so on up to the representation of the good shepherd, which was an especially favoured theme at the dawn of Christian culture.

Among the sarcophagi, perhaps the most famous from the pre-Constantine era (although the chronology of these sculptures is very uncertain) is No. 181 in the Lateran Museum. It is known as 'The Rams', because of the two rams that frame the composition. In this, and in other sarcophagi there was a return to the narrative style, realism and natural solemnity that from the days of the Ara Pacis have always represented the best qualities of Roman art.

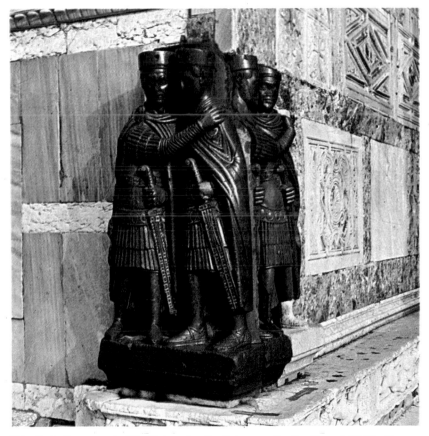

99 *Late Roman art : The Tetrarchs. Sculpture on the Basilica of St Mark's, Venice. c AD 300.*

99 Late Roman art: *The Tetrarchs. c* AD 300. Sculpture on Basilica of St Mark's, Venice.

Porphyry was one of the favourite materials of the court sculptors during the age of Diocletian. A good example is this group of the Tetrarchs, in which two pairs of Imperial dignitaries embrace each other, as though to signify the unity of the Empire.

100–1 Roman art: *Colossal heads*, thought to be of *Constantine* (left) and *Constantius II* (right). 4th century AD. Palazzo dei Conservatori, Rome.

During the third and fourth centuries AD, the centre of the Roman Empire moved towards the East. This movement was very important for art and the Imperial portraits of the 4th century reflect the new conception of the sovereign; he was no longer, as he was in Rome, the first among equals, but now he was an absolute master – as in the Oriental monarchies. The enormous size of these works (the bronze head of Constantius II is about 5 feet 8 inches high) and the powerful, frontal, square shape of the faces clearly emphasize this new interpretation of majesty.

102 Early Christian art: *Oval sarcophagus* in Santa Maria Antiqua, Rome. *c* AD 270.

The Christian religion, heir to the Jewish tradition that had forbidden material representation of the divinity, chose in its early days not to produce sculpture in the round but instead favoured the relief, which was widely used, especially in the decoration of sarcophagi. However, it should be remembered that these sarcophagi usually came from the same workshops as those with Pagan reliefs, and could only be distinguished from the latter by the different themes they treated.

103 Early Christian art: *Sarcophagus of the good shepherds.* 4th century AD. Lateran Museum, Rome.

The reliefs on this sarcophagus, packed closely together, the figures rather flattened but made to stand out sharply, depict the recurring motif of the good shepherds; the overall effect is decorative rather than emphasizing the allegorical function of the subject.

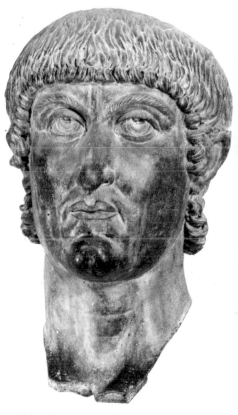

101 *Roman art : Colossal head,*
thought to be of Constantius II. 4th
century AD. Palazzo dei
Conservatori, Rome.

100 *Roman art : Colossal head, thought*
to be of Constantine. 4th century AD.
Palazzo dei Conservatori, Rome.

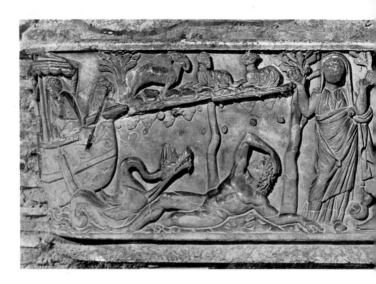

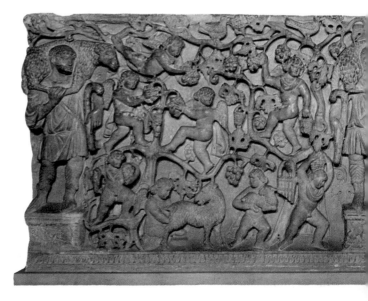

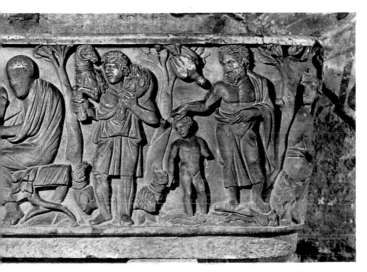

102 *Early Christian Art : Oval sarcophagus in Santa Maria Antiqua, Rome. c AD 270.*

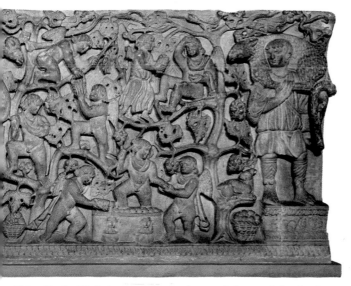

103 *Early Christian art : Sarcophagus of the good shepherds. 4th century AD. Lateran Museum, Rome.*

BIBLIOGRAPHY

R. BERENSON, *The Arch of Constantine – the Decline of Form, London* **1954**
F. E. BROWN, *Roman Architecture, New York* **1961**
G. M. HANFMANN, *Roman Art, A Modern Survey of the Art of Imperial Rome, New York* **1964**
G. PICARD, *Roman Painting, New York* **1970**
D. E. STRONG, *Roman Imperial Sculpture, New York* **1961**
M. WHEELER, *Roman Art & Architecture, New York* **1966**

INDEX OF ILLUSTRATIONS